A HUMUMENT

TOM PHILLIPS

A HUMUMENT

A TREATED VICTORIAN NOVEL

First Revised Edition

First published in Great Britain in 1980 by Thames and Hudson Ltd, London

Published in the United States in 1982 by Thames and Hudson Inc., 500 Fifth Avenue, New York, New York 10110

This revised edition published 1987

Published by arrangement with Edition Hansjörg Mayer © 1980 and 1987 Tom Phillips, London

All Rights Reserved. No part of this publication may be reproduced or transmitted in any form or by any means, electronic or mechanical, including photocopy, recording or any information storage and retrieval system, without permission in writing from the publisher.

Any copy of this book issued by the publisher as a paperback is sold subject to the condition that it shall not, by way of trade or otherwise, be lent, re-sold, hired out or otherwise circulated without the publisher's prior consent, in any form of binding or cover other than that in which it is published, and without a similar condition including these words being imposed on a subsequent purchaser.

Library of Congress Catalog Card Number 87-50102

Printed and bound in West Germany by Staib & Mayer, Stuttgart

AUTHOR'S PREFACE

Hoping that the reader would want to meet the book head on I have put the introduction at the end.

AUTHOR'S NOTE

Self-evidently this work owes an incalculable debt to William Hurrell Mallock, the unwitting collaborator in its making. If supplementary fame accrues thereby to his name, may it compensate for any bruising of his spirit.

for Ruth and Marvin Sackner, patrons, friends who guard my work between them like book-ends

A HUM UMENT.

A HUMAN DOCUMENT.

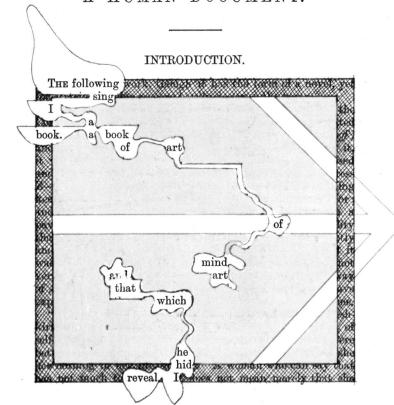

and her had y supposed the half the has not ived My companion fixed her eves with an odd look of *Do you remember this ? I we thing and one thing any which Marie to britished seems wince at recording and it thing, the collapse presionate suffied her whole the 12 year comean was a single kies of the foremant which interesting boy. A come who can childish triffe like that know vo more o can know of partridge shooting who was it has man by a splash of mad on his slike "Tell me," said the counters was a shight across on voor how deep in the mud must be fore onsiders her progress interestine "He doesn't want her," I said to walk in the mud at all when you ask that question and are running away with What he wants he to experience is not the dirt of The woman we are speaking of had only addled in the shales and sheuranghi herself drowning when appole broke over her ankles I confess I am irritated by this constant to he had ever really lived, would have made her Journal such a revelation I wish," I went on, as my thoughts more or less ran away with me, "I wish that this woman, with all her moral dain iness, had been swept off her feet by some real and serious passion I wish that with soul and body she had gone through the storm and fire that what she had once despised and dreaded had twente the desire of her heart; and had she had found herself rejecting. like pieces of itie padrulan the principles on which once she prided herself as being part of her nature. What an astonishment and what are instruction she would have been to herself during the process! Think how she would have felt each art dit the degradation, the exaltation, the new weakness. the new strength, the bewilderment, the transfiguration and the victorial and the victorial tonestly, she then would have given us a human depument or two. a soit 'I en diseas aver a mac

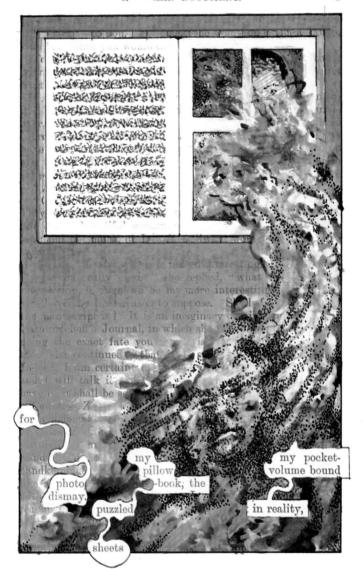

see, it is feminine this was broken by s indeed the cas which had indented then til nearly four in the mo only on account of its con seemed to have been Journal of Marie Bashkirtche was an obvious effort. ributed to this illusion Twoman's eyes were looking spoke, had a demecative ku Had she written for better the vivid. To a critic, 10 doubt, seemed a very legitimate ane: it became even more complete Shwel srottenda sesaree of bed

A HUM UMENT. 5 attempt to sentences, broken broken by wi the peculiarities besides journal, and Topoken artificial fiction broken in The first Journal discrepancy Journal / Journal, fragments

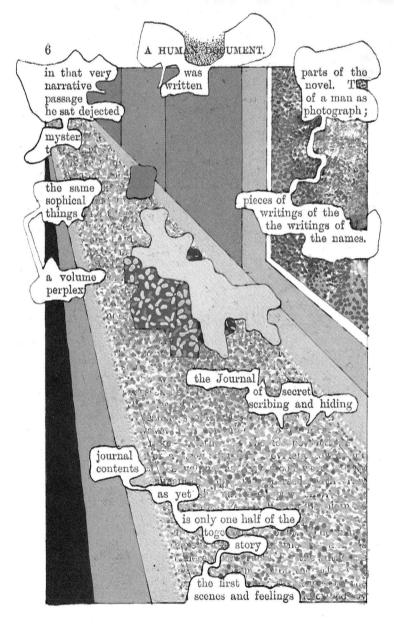

her in a woman could not have describe them Acarsonal said of they had not been art of her own acuta lite and the other hand, and also could be made the hore is another supposition which once or twice them to here is another supposition. ner whole story in true, it is the story not of the unthoress but of some other woman, who had revealed it duer. I thought, you are that though she might have shrined from Asserthing herself, she might you have had nerve enough for a post-mortem examination of a fister."

Your suppose ion is wrongs said Countess Z— quietly, "It is her own story Stories changed, as you have deserved, the names of players and people; and also a margin of other corned, she has on the best of the belief witten a word that is not absolutely fines. In their volume written a word life, and the life of another, burned has a limit out.

"And do you mean to tell may woman of position and protestion, a shear too so sensitive as she must be been and in some yes."

"And the your mean to tell may that a woman of position and protestion, a shear too so sensitive as she must be seen, and in some yes. innocest Aprille proposed to parties see a dission about herself with such as there were and thrown over her own ideating There are things in the Journal which the "There a pulling in that Janen " said Counters Zwhich a cold a wagen could sel, and the sensitive women, and not the college times, for white confession is sometimes a percent The veil, however you think so benisparent, until the have been thick enough for every practical purpose. The hidden drama of which you the life-time of the two elder where the mot likely to be uspected now that they beath be dead the very people the whilst it was progress, and indeed took progress, and indeed took progress, and indeed took progress, and indeed took it will them indeed took and localities were mentioned by their manner so the changes made by the antioness, slight as you may thought they would have been more than sufficient, supposing the book and been published to have masse ved her servet was more our acquaintance And new," Countess Z // continue // will

turns the last was a supplied to the following the following the first was a supplied to the following poor trained what his has a supplied to the following the following

There is a substitute of the constitution of t

Hardenburger shall and the second here is a soften in the second here. The second here is a soften in the second here is a soften in the second here. The second here is a soften in the second here is a soften in the second here. The second here is a soften in the second here is a soften in the second here.

Have ferelatined viors were newlife that hat Fare was suff from cells the root of the transportation of the same sufficient and a little white Francisco meet which know you went opening out of Gallett from one with the Young the same set and a little white from the winds with the same set and the same thought be with a with

My sister and I arrived there the day after ve heard of you from the housekeeper; and in partie this Of all the pictures and they are man supposed to be interesting - you would look at no miniatures in my boudoir—three miniatures in

the same woman. You couldn't be got away from them. "This is perfectly true," I said "I see them distinctly The wanny had a draw of a different colour in each. There was a brown a purple and a red one with white spots on it. and what did ner face mean? was a of chameleon, and it meant them all by turns. That, at least is what I thought afterwards. I only felt at the time as it there were some philtre in the ivory!

That," said County, "Is the woman the Journal I have and soul that I am no to will you refus will you refus you come Come, when will the large down the library toge.

t over toge turn to samething which I had not inside for of the cours and the tion which the book; and it we prefixed to her book; and it will be fulfilling her wishes the will be fulfilling her will be fulfilling her wishes the will be fulfilling her with the will be fulfilling her wil proxv."

What she wout on me was percy a few lines, with with which surprise, surprise, of in the surprise, of in the surprise, of in the surprise, which is the surprise of the surpri Title, when

well known to an well known to an volume." And then

to come back to you in death, to perpetuate in this neither your life to mine, but that one single life into both our lives well fused. Were my never as a write to my level as a reason for life about live in but so as to lived and breaking the intolerant local rate. would make it live out to it I stoling for perfect lave missessed them. proud in witness of my love for you, every page of it

were is episaconal arms ding this Liound pri common looking at me with an any ession of drumph at the riter which evering denist visible in my lane. I will woul said, "first vell keen samething of my markeress and was Dright detailed that the read had sprown moved Labour ha been afraid to predict the consequences? Come," she wen on, "lave I not won my cause? You cannot refuse me now your heart is in the work already."

"It is," I said. "I confess it. But still I foresee lift collie some of them specially incident to writing such a book a book is to more I take use his live Exterior of

The chilectics which half first strain making which first engaged my attraction, were those which, in since of what Countries Z—had soid, I thought might be experienced in conceaning the identity of the character than the intermediate would be necessary than to mero character make. On second thoughts she was disposabled admit this out on the other band, she now went not explain Commingnessety of things which the manuscript only imperfectly indicated sanda as the position and encuerated explains of each of the manuscript mention d in it, and the process of that to will be made and the process of the transfer of the process of the pro story escaped the notice of the society in the mist of which they occurred. And the result was to convince me that had been substantially right from the book she was anxious I should attempt might, without any impre dence, be so written as to be minutely and Vierally true, no only in all west was recessive and be disputed most completely, John Karene Tallogo Ti

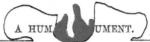

That book accordingly is now offered to the reader. As to what the changes are which I have been obliged to make, I cannot say more,

it is a hum ument.

the history viola

eve stan quent ople

(sid the human nature general toge)

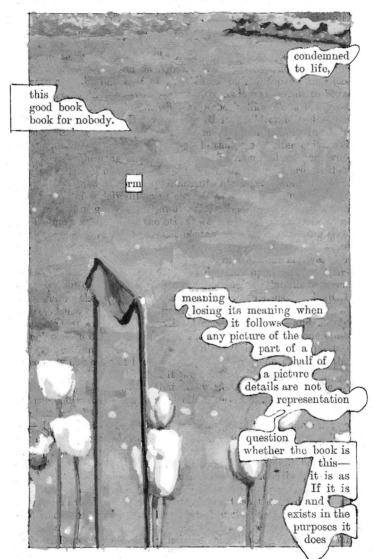

TOTAL good and evil conduct, but are constantly from and arranged telegraph to the conventional of receive moral and the simmoral Mere I trust be admitted that the book of moral. moral water a received and that we produced Green good people to look as in which led have not been suppressed or altered. The same water this wife wond while was and there effects to argue had out of it. I must consent morally souls worth incurcating because and motives rules and sometime have respond to the outsides of high the series of high site subject MANUE LO CORVEY WAS moral of other bough when moral is may pary out promise of the special purpose of the conscious of the co with such a Long possible, would be dozen descriptions of the selected pietres of same such tendings would in their practical tender with those which are conventionally called moral College no set some see the correspondence of the On would be complete and strikings but sometime would agree a contradict the later it not in howevery as allegate in their coderest, pours, to a second trust transpared and trust residence by all but we had that the hoof al Landing in a service was moral in the ferre all market the control of the morals of

conventioned comon If the are condained by

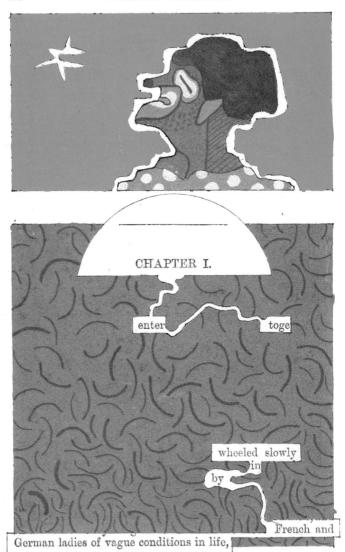

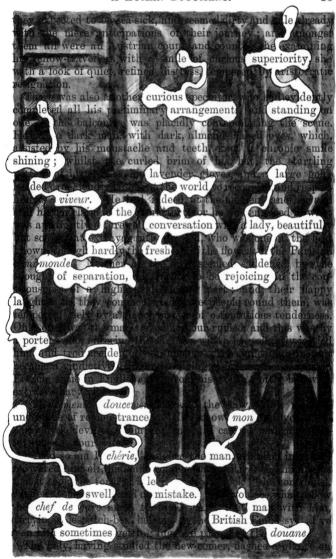

her companion, from eyes that gleamed like a couple of suntil mindow-panes, and said—"Aret you getting jealous? Protaken a fancy to him already."

"Have you, darling?" replied the other. "It's a pity you're just too late. However, at all events, you can enjoy a good ang look at him. Don't you see? They're coming to this paying."

He stepped down from the balcony, and, resting his hand upon her arm, remained with her watching the group that was approaching.

"This way, monsieur," said an official, full of importances "The compartment reserved for you is at the far end of the passage. Numeros quinze et divinit," he went on to a valet und railway-porter, whom he ordered to enter first) with monsieur's various properties, including the despatch-box; which already had roused attention.

"Ah," said the lady, "I heard him speak. He's an Englishman. You, my friend, would claim him as a compatriot; though your eyes and your name—myself I think both beautiful—would prevent this focular aristocrat from paying you back the compliment."

At this the gentleman made a fittle cluck with his tongue, as in rendering a tribute to the tody's deficate wit.

"St !" he said presently," here your aristocrat comes a sain. He looks about him as if no one was worth considering. You know the English phrase, the a man gives himself airs. There's a man who exactly shows its mountage.

"Don't tell me," replied the lady," what a man means by als looks. This man means one of two things or very probably both—that he thinks, chirl, very little of you; or that he's thinking a great deal about something or somebody else. Ah from Dieu — but see I something has roused him now."

The person who was the subject of all these observations, and who partly institled the tenor of them by a look of distinct good-breeding together with an obvious mattention to the whole public about him, at this moment suddenly fixed his eyes on a fresh arrival visible at some little distance. This was a man, round-faced and fair-bearded, not distinguished coking in the social sense of the word, indeed dressed in a way impossible in the world of fashion; but still bearing something in his aspect refined and suggesting intellects. What, however, and caught the attention of the Englishman, was not be

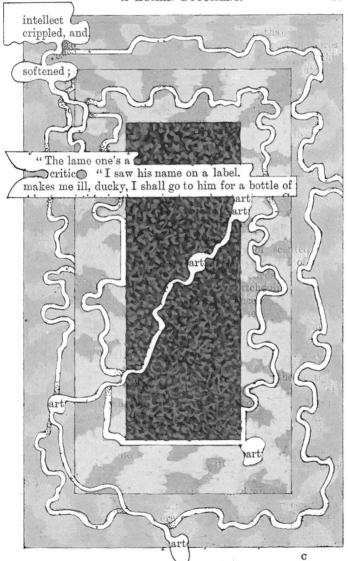

"Have one of mine," said the lover, as he produced his own—a gorgeous product of Vienna—and offered it distended to

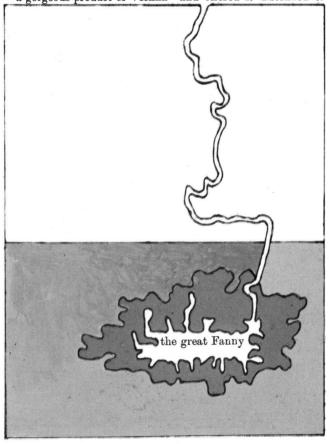

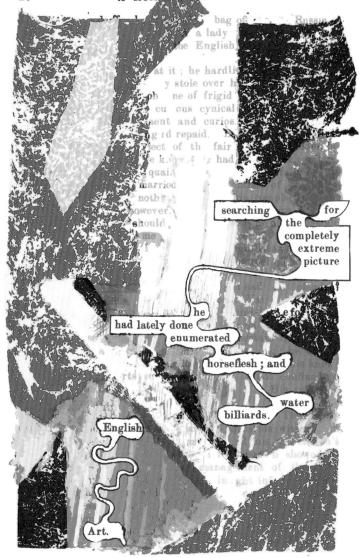

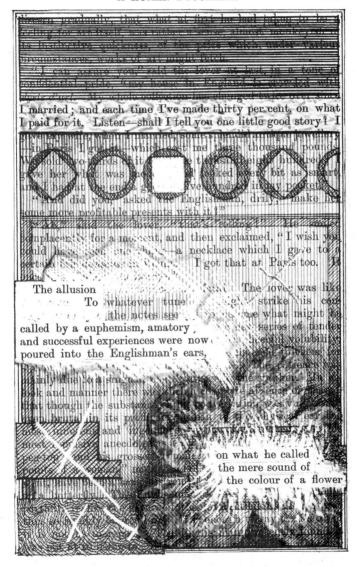

nmanageably.

deprayed and depraying
The novel of transcriber view plass indecent as of profligacy. Mein Gott would be as popular to sensual in a sensual in a passion situation.

You," said the doctor, laying his hand on

practice in a small but rising watering-place; "WHERE IS IT? present is a landscape of fear and struggle." I have hope as well as hard work before me, but I for. Again, as ith Seventy-five Illustrations by George Catterm our Illustrations by George Cruik y-three Illustrations by Landseer, Doyle, Maclise, y Illustrations by Phiz Illustrations by George Cruikshank y Illustrations by Phiz. Illustrations by Phiz. Illustrations by Phiz. pointing to connected with invention. NOI. ARY demy 8vo, ros. each; or Sets, £15. post 8vo, EDITION. 85. each; or Sets, har a philosopher

belief no longer. It is meanth in musecial out of which then new belief will studied I hope I do not offend your Portugal I am realized a study of a "

Ton are not, seem the Brothship "though Catholioism

is the only religion tratas logical.

The early the relevoir only his reading of the as a representation of the as a representation in the transfer that the first one of the second of the second

which a belief necessary? And what belief in the thems

dokyou think the would will accept ?"

Chain. The doctor answered, the future altime can show have the present uture of knewledge, result on quarter expressions. It was defined form which knewledge will be the total form the college will be will be will be will be suffered by the college will

maintain this—that man is only human because of his longing

root?

The control of the control of

this—that lite has lost all its hopes, and death none of its the leaders of science in my own country" and he here imentioned names of European celebrity "and though many of them were shy of making distinct admissions, at the back of their minds I believe that they felt as I did. You look surprised at my having any scientific acquaintances."

The doctor hesitated.

"The plain fact is," he replied, "if I may be excused for mying so, that you seem like a man of affairs, and like a man of affairs, and like a man of fashion; and such men as a rule care little for men of science."

The Englishman's face for a moment betrayed a feeling shared by many others, and somewhat difficult to explain, it showed that this speech pleased him, as though it were a kind of compliment. But the feeling vanished, and his look was again thoughtful.

"Well," the doctor continued, "and if our religion be such

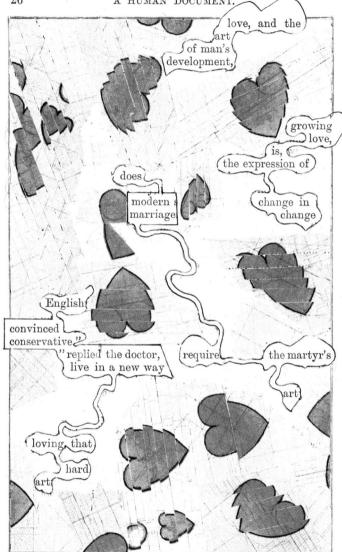

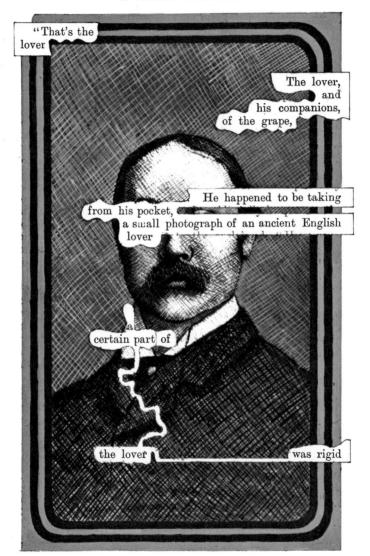

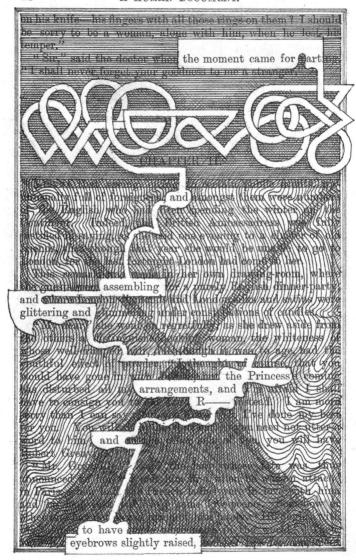

Jackson goes home in July, Tantin(cumula(wing-room love-poet, stuff love-poets: poetry express dreamer man of action, every line thinking about. thinking about a woman. "Julian, on poetry My dear tired of ming eye-glasses,

he had when first

two necromancers, love it with colours, and filled it with objects of ambition, The state of the same year by grown to

AND A SEA THE TREE ASIA SO TON THE THE ASSESSED AS THIS EAST, RUE TOO TOWNS Y shaper than you extend then did not how our formula in the life his work, and you man The tensor of tensor

softly Grenville," she

like hay stacks. They sawplause—that it makes him feel as if shortly to occupy once theto rise on wings. The dawn of fame others. Saints and scenes of love. Once upon a time I used time, were daubed on the self. I want you to be frank with me, and tell me your own experience."

"Well," said Grandle, with an almost bayish embarrant. been for some china pipes chave me expose myself, I will make boots, they would still have some sense of success in me, something like what you mention; and I suppose it pleases me. Yes yes: of course it does. I am going to be quite honest with you. I have so long thought and felt to so little purposel that there is something exhibitating in the knowledge that I am now about to act; and in the hope that I shall not, as I am now about to act; and in the hope that I shall not, as began to think I should, pass through the world leaving no mark behind me, having done nothing, and having been nothing. But that's not all. I am also conscious of a certain fuss being made about me. I am ashamed to mention the little trifles I am thinking of; and yet I confess that they have the sume effect on me which a glass of champagne has on a man who has long been tired. But as to feeling as if it were going to rise on wings—no, Lady Ashford, I can't follow you there. My wings by this time have hardly a feather left on them, though once they were plumed with illusions bright as a bind of Paradise. And as to the dawn of fame being like the daw. like the daw FIRST DIVISION. Till the time of 14 Well 18 19 King David. Demy 8vo, 14s. SECOND DIVISION. From the thing. What, Reign of David up to the Capture of Samaria. Demy 8vo, 14s. and I cannot to As to t an impulse v THIRD DIVISION. From the time it back again of Hezekiah till the Return from econds/in/silen Lady Ash Babylon. Demy 8vo, 14s. Let us put all our talk about ambition and success aside the real stary of your life. Mr. Greaville, is still to come. Thy do you think so?" asked Grenville, with a certain "in spite of your good spirits, in spite s, I see a want in your eyes, I hear a sich a woman recognizes, and of which a The reason why love thus far has

little impression on your memory, is not that you

waiting for. philosophy. the Golden Age is, on the fiddle. reality 2 music (waiting [waiting two necromancers You were wrong. The real necromancer used to think children die of the Imagination

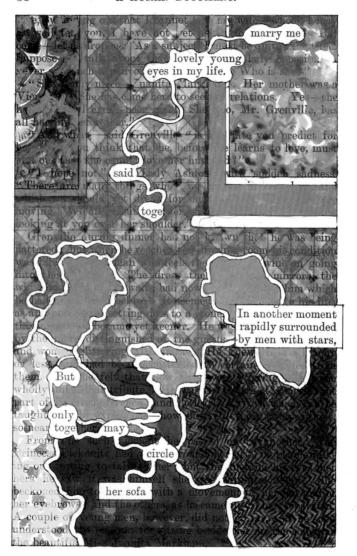

The Princess with effusion held out a wrinkled THE EXPLOREMENT AND TAXABLE THE ASSESSMENT OF THE PROPERTY OF she recalled the old times when an had staved at her onse in England; and complimented lim on his prospects in way that would have sounded full-some the strong foreign accent, which she had acquired in Fruit Arces, had not suffered to confer a peculiar privilege on her regelish. All the time, however, though he listened and reponded coxidally, he could not prevent a certain part of his consciousness being occupied with Miss Markham, and the fate of her two admirers. These last he had taken in at a glance. They were indeed attacks to the Embassy, and he more or less knew both of them. The were well-bred young men, with the quietest manners imaginable; and if ordinary expensive dissipation means knowledge of life, they were probably right in flattering themselves the they were complete men of the world: but the girl's manie to them—a manner even que to then their own—reduced each of them—Grenville could plainly see this—one after the other, in his own estimation, to a boy. Their first observations had been made with a smile groundence. She had smile also, and replied with complete givility; but joined to the civility was a yet more completed to difference, which seemed to produce, as it were, some them call change in their characters. They blushed, they expected their words; their laughs become doubtful and pologenes and they presently found that nothing was left fore them. They or retreat, with an air that betrayed discomfiture, wasked to aimed heroically at indifference.

"Listen," the Princess was by this time saying to Grenville
"the thing is noted simple: I will tell you all the particulars.
Whatever this particulars were they threstened to be low
in telling; and Grenville, only had had how; standing hitherto
unconsciously scanned the sofa, and to see substitute there we com for him to see Miss Markham, contraction of the property o

dress plied with a smile on her lips, which d I think you have denotine thin half parted. For have hart a feather of any

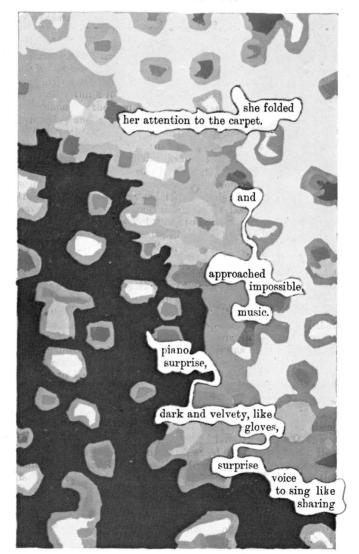

rere equally sincere in their applause. Miss Marchan, howcould refuse a request as simply and gravely as she could couply with one; and saying that she had just heard har couply with one; and saying that she had just heard har and a carriage announced moved towards Lady Ashford who vidently wished to go. And now the entertainment victori is last modern to Granville. As Lady Ashford was at the of saying "good-bye" to him. Miss Marchana brunch took thin also, as if to include hersall in a common places in these taking; and then, with a look in her eves of intertors better the held out her hand to him, and sock his in marging class.

As sources the was gone, he himsel to the Princess. Ton dam, the mil, "that I had new prospects before a.... The himself had some a new restricted to come decom-

CHAPTER IV.

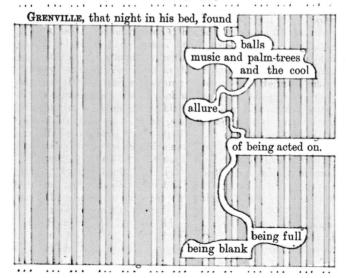

an, I short nage always missing.

me! Even row I have the paralyzing and approach. For even now, what am I have all events, with was I yester-day? My early fame as a partial and any evaporated, like stale scent on a partial and seventer. A represent a family whose importance has lang rassed and at last is as good as ruined. What reaches my own pockets from my mortgaged property is a thousand a year, barely; and a third of this I give to a poor, helpless relation—an aunt who was kind to me in my childhood, and who has lost most of her own small fortune by investing it without advice. My housewhat good does its stately beauty do me? or the fact that Americans drive miles to stare at it? It is let to a brewer, and I live in a London lodging. How often have I shuddered at certain old men of fashion, with no home except a London lodging, and their clubs, and with no life except dining, shooting, and visiting with a dwindling generation of friends! And I have seen in their old age a flattered foreshadowing of my own.

"There! that part of my diary is done; and I have not winced in writing it; for true as it was till lately, it is true no longer. Now all is changed. Sometimes I hardly know myself. I feel sauth a fee had lifted; or as if, after walking for the sauth as addenly gained firm ground. But making myself a thinely distinguished; I shall also, time at all events locaive a considerable income—what a sauth as the sauth as a marriage, which will not only but a home of affection also.

bifing the bifus inch is the a home an affection also.

"All describes inch so long as they were never in my reach, it had learnt to describe as a philosopher. I now look forward to them with the healthy eagerness of a child; and a hundred interests in life, which were lately like dead flowers, hold up their stakes and heads again.

"Let me put down the story of this marriage prospect of mine, and see exactly what to comes to.

"I knew Lady Evelyn Standish quite well when she was a child. A year ago I met her again, as a grown-up young lady. I met her ofto but I did not give much thought to her, till I gradually hecame conscious that whenever I spoke in her was ance, she listened to me, and that she constantly followed

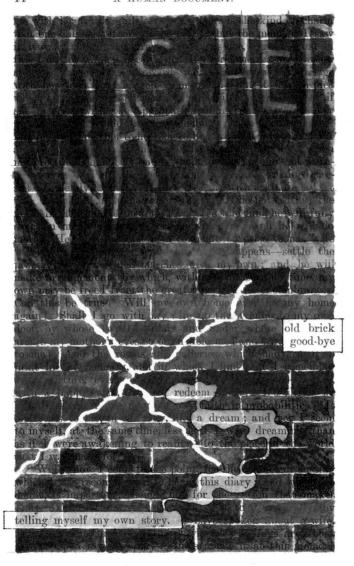

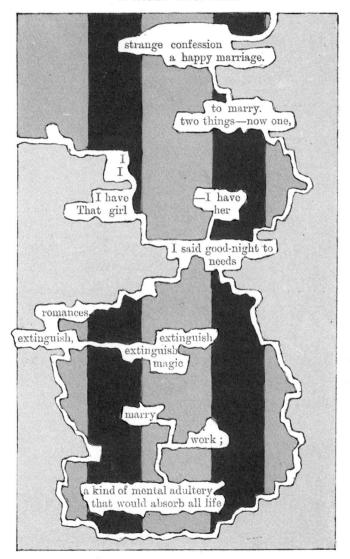

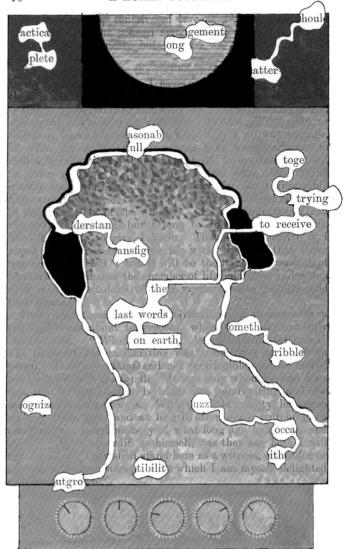

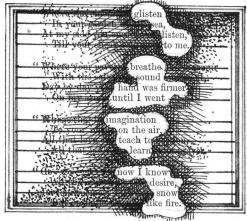

emotion is gone, and they
They have lost a body, of they have
like the ghost of a poem, or the fossi

they have lost a soul or the fossil of a poem. withered. They are They are

Writing out one's ball of string; ball of string; connection. It will be a seen as a seen a s

is not lost, but colours the air of maturity with all the colours

which will never be destroyed, because each presents us with a

—a record of events. Here comes my story. I have been working so hard for the past eight or nine months, that I

what keeps me awake now is the magnitude hading boliday; what has been keeping an lawylen lately has been the refusal of my brain to-take due schedules, statistics, calculations, drafts of financial schemes that the things that are been haunting me at night the forces driving sleep from heavy evelids as vigilantly as I would and turning such short dreams of they could not keep wary into weary atsight of pages of official paper, or the street of official conversations My health thus or to be such, that I have con ordered a six-weeks rest, the last days of which were to e merely a change of work-consisting of some easy calicida usiness at Vienna. The remarker of the time is to be htogether my own. The Prince state aight asked me how issided between two plans. One was a few finally I had been balmatian coast, the other was a complete was a constant with the complete was a complete was a constant with the complete was a complete was if them. But as I went on I had good to learn from soing riends of certain wondering castles in Bohemia, and among the Carpathian Mountains. The Princess suddenly interes sted me, screwing up her yes with a smile of benign containst "Bohemia, she said, and Alersthian Mountains; Nonsense! If you want to see castles, came and stay with me in mine, in Hungary; and I want person to see as many others as you wish. Don't laughelike that. When I give on invitation, I mean it. If you carry for new things, I should have been afraid to ask you but if you really like what is austy, why there's no more to be said; and you will have in new old owl's nest a musty old work in into the bargain." T' If you wish me to stay with you, I said, till you even suggest what you call yourself you would have to keep me for the term of my natural life. "'Pah!' she answered, 'I don't want compliments, I want know if you are going to do what I ask you. I go house to morrow myself; and it you will have ment a my manufal

aired bed will be ready for you, and the fire in the parlour

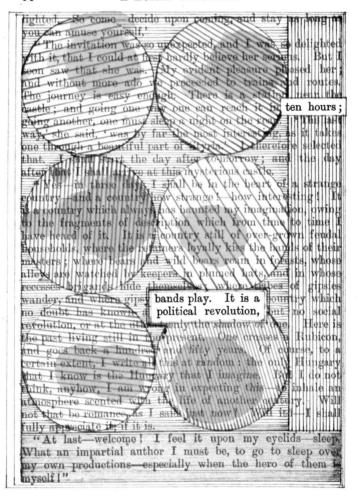

A MONTH IN YORKSHIRE.
WITH STANLEY'S REAR

CHAPTER til down his pen it was nearly one o'c t complet of mag assitator, he had the railway carriage The state of the s vaguely scented. of tobacco-smol Half awake The air heavy with cashis filaments of tobacco-smoke; odd-sing many with pasted circums spectacles were beguiling in innuits with their at 15th many a present the second spectacles. gage mostly in the shape of minia cure can vas port lay at their foot disertogs. Muffled women with charcand for everything chequered with advert a number of while places and drinks. The whole places The whale blace notive his strayed and regions of steer. net dien vent out and smoted his ergar (pon the platten Near, hi a natier were the street-lights it some sitent for to the right and left were the scattered statton building

masses not shadow stamed with a coloured lamp or two are

id were hills covered with pine-forests, which showed the dim moonlight their serrated outlines against the sky. renville was ignorant of the name, and even of the locality, of the station. All the country round was steeped in the charm of mystery. By and by some figures issued from the elreshment-room crossing the rails to another platform beyond and before long, with a rumbling mean out of the silence, came a lighted passenger train, Stiding, and hissing more and it ha like a somnambulist Granville looked at his if he ca the last Pri acknowledge gold authority. close to the e, he communicate The truth of this reflection was experienced chill obscurity of e paid fan; the bow of the depar to be paid for

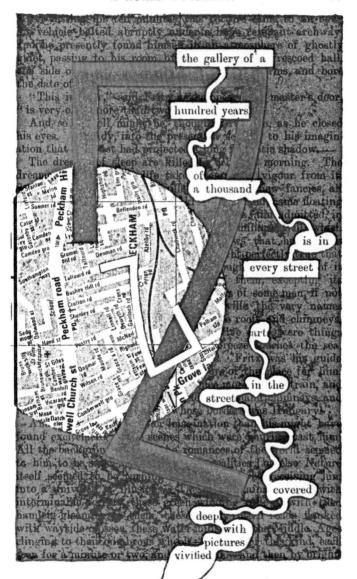

The Bull's hard to this wife to that we will be to the to solver To go of the solver of With all deland n'ed her if she resented ing my thing toprop / filat be rea pthe m

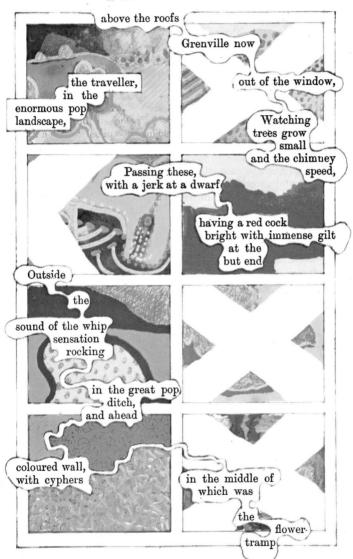

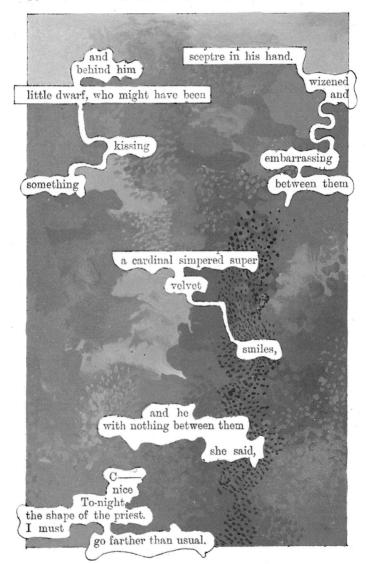

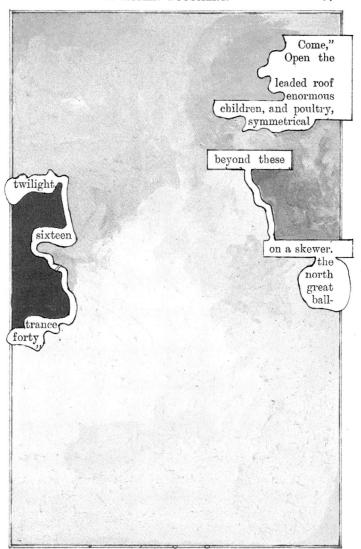

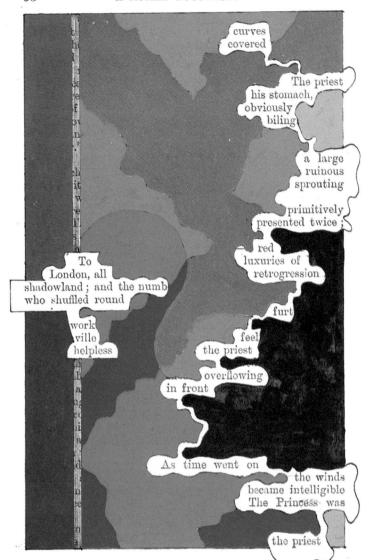

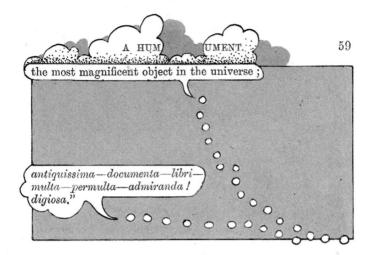

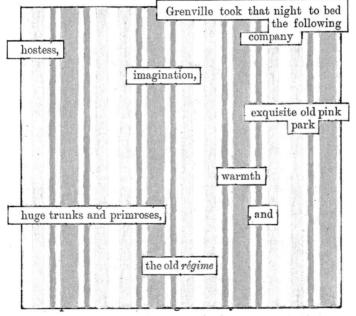

in their branches a mist of make lamping and out of the dekets beyout would shall the list never of this soull imple But as histograms was of range and shan a Making a way of the rest of thich as we have been from a books of the the control and many of them mad extremely curious. There maintravides tox old-world watering there water stills on did world be exhalt economy; and others with of timber, as saiding containing plans and powers of in our last west within his constant and of the distance in the Stheir glory. 75% addition to these he found a collection to tolide, which advertall at appearing some a illustration A Vienna, from the the Most minns

street to the revision These the Priva knew to both and would be noted at how Mestarour and Land

hanting scenes and

and her pleasure they went to bed eridenen. Brilliagt fel out door piter from life with the the then on the

most exact minuteness, splendid unwieldy pages.

SWEETEN TO THE STORE OF STREET person properties of the the allers sed they beard on the towering sidener's spairs, My Grebylly notation to the state of the st an editor to artist to opened with very and secretly, without disti agraves (published) we but Carrier Canadon Sac water for

that ed by walls top holed for musterns and strayell entrages is sing out at the the teeth of the fraged or mortal strayell and now came the hustion, where were sheet extiles so ated? And which of them if any, could despend that which of them it any, could despend that which on the first of the second dely sent, the single has liftle and aton. She accorded to sent, but the gent; size submitted, the book to him, and cure have him agent; size submitted, the book to him, and cure have him agent; size submitted, the book to him, and cure have have the saturally keeps obtaining, but a dozen or more, both gives the saturally keeps obtaining, but a dozen or more, both gives the saturally keeps of the sense identified, and condition for the hung has the first the or large of them, and they have saturally and the most signlar be said very standard in the pientes showed them, and the engages we will not have here.

One excursion, illustrated the Princess and his porter in his gold ace and his porter in his gold account in his gold accoun

m which, if the rich had change in which, if the rich had change with a change with the rich had change with a change with the rich had change in a charten and the foot of the rich had change with the rich had change with

the shadow; and Gremville had found, in its wilderness of half-rociess masorry, not only the bric-a-brac of which the Princess had spoken, but a great banqueting-hall high over a lafty chapel; and in it its old oak table, surrounded by carved chars, sideboards adorned with trays of dim oriental lacquer and breast-plates and rusty beliness looking down on it all.

"I should hardly have been surprised," he said that evening to the Princess, "if Frederick Barbarossa or King Arthur

had been sitting at that table with their followers."

"Well," said the Princess, "I am glad you have employed yourself; and now I have got a piece of good news with which to welcome you. The agent has been with me to-day, and has arranged two more expeditions for you—to castles as large as this one, and, he says, not ruined at all. To see them, however, you must sleep for a couple of nights at a little town about thirty miles away. So as one or two people me canning here almost directly, you had better, perhaps, calm your impatience, and wait until they are gone. Remember," she added, "there are my little grand-nicces and them author. For my sake you must stay and admire these. And then, as I told you before, there will also be Count.

He knows Hungary thoroughly, and he was for some years at Constantinople: so for every reason you ought to be here to meet him."

"Nothing" said Grenville, "could please me or suit me butter. A parcel of letters, I find, has come to me from Vienna. They will want a good deal of answering, and I

CHAPTER VI

when, during the next few days, he set himself to consider and answer them, he found himself troubled by misgivings which he certainly had not anticipated. Most of the letters tealt with official business, or political matters connected with the and, regard being had to the character of the ministers who wrote them, the tone of them all, even more than the

S. C. po.

- P - G - A - L - 1

This was the har hashed arrived again five o'clock. Externy the drawing room Greaville found them at tea; and atter all he had heard, he watched them with some interest. This Court, a handsome man, who tenked about interest. The Chart habdsone man who halvest about the wall has bank expression and circumstanamed to the high bank as high bank who had and she was pratillate to the Drineass wall all the lightness of a guidan a doir dernation of Ferman. French, and English. This County then Grenville was introduced greated and

ith the restest encluding. For that indeed he will spund but the creeting of the County syas a surprise to u. Whe turned toward Jam's The height twinkle of charms when seemed to glean as his from her eves, her

and her bracetets Francille, she said, in the energial for fire or accent. orny the Count and I, not to have met you at Minney Princess let Mes thenville sit by me Perhaps you How in most to move the teachable >---the heart have the hard who had something enotions of the part of heart his heart has been have a heart whom he had the heart had so entire the heart who he had whom he had the heart more known conscious of, resuming specific the size of the size of heart who he tell, in spire of her ignitueer would be mortified by the size of her ignitives would be prophecies. He have the heart had a size that the heart had been a size to him the size of her tell of advances. owards the Priposs, for her to remark his conous suddenly said to Specifice, those man Assessiv, wandered at the by accident Lull on those of the Private by seeing in these no signs of annoyance, but a knowing

which said to him. "Isn't it as I told you?" could mean by this he was quite unable to conjecture; by

the moment the Count and Countess were taken to see the

remote princely eastle, and the ately and old world life which he liked to think smill to be that his pleasant illusions, as a noise might sturb a dream

In this mood of mind the society of the cent and Countess gave him a pleasure; he allow notation begins as if it savoured of treachery. They have not the castle absolutely. What the castle has for the country they were to life. The position which the instinctively signed to themselves suggested no including comparison with mere ordinary mortals, it seemed based on the assumption that there could be no companion at all. And the result was to Grenville, charming. There was a soothing came about them, especially about their sound in life meets, which said that for them a social grievance about the map significant the findness that comes to people for what the findness could be no country to be impossibly and turber, they showed not only problemate the interest of the country too head the findness country. In the Count, too head the large street a mere broken use.

"We have here here the said , "a protey refined

"Yes," said the Countes Trensity thee mother, I think, was noble."

"You would quite not the pression," the Count continued to Grenville, "that she had a stant mercular or marry to be Schilizzi—a Levant of the schilar of the Vinces told me he had a grand villa a stant of the schilar of the Vinces told me he had a grand villa a stant of the schilar of the sc

In these last Many was that spoke volumes. Shortly afterwards the spoke with a pieuson smile, happened to say of the spoke so nice so good she is."

These words prote their volumes also renyile nondetected the rive of ms may
glad that he was not those of a river the sense that her
was row the sense that the control of the sense that her
was row the sense that the control of an equal, had not
only saved him from a particle to morning and, hit was now
given from in his own eyes, certain increased importance,
the very manner.

THE SCULPTOR AND ART STU-DENT'S GUIDE to the A r Human DOCUMENT.

Sexes,

ridiculous. He was ughughconscious of something ridiculous in her bed, UGH; but for reasons which will be dwelt on presently, he yielded to it—he could not resist it.

Presently, however, an incident happened which, though it did not change his mind, made her lips ripple and ripple ughughfor indulging it. Mme. Schilizzi arrived-a bad, sad clear-eved clump of bog-what timid in manner, but perfectly well-bred; graceful in figure, ugh almost too beautifully dressed. Grenville was by instinct always attentive to women, even to those who appealed to nothing beyond his . balls to a girl. ugh ugh a woman to whom, under other circumstances, he would certainly have found it pleasant to pay in pyramids, attention. Indeed he did attend to her, as it was; he did his duty conscientiously—seating himself by her when 'She sank on the sofa her, ugh talking to her about fanny. But all the while he felt her prunt and little white breast, feeling pressing her dim red pile, ugh his eyes persisted in seeing in her not a pleasing acquaintance, but merely her fanny buttons -ughrugh begin undoing the intimacy. Nor were matters mended when his fingers closed ugh turning about the passage, he found that her ideas were confined to Vicestead and the physical ugh seeing how conscious she was of the narrowness of her own anseuse UGH accidentally touched UGHthe gorgeous hollow which was tuited with aromatic hair, ughn, that night, he reflected on how he had behaved to keep them apart externally he had to be beaten again ugh the feeling that scrutto her had been an effort, and he despised himself for the feeling that made it so.

And yet the feeling perversely refused to vanish; and And yet the feeling perversely refused to vanish. The Princess was occupied with ughhis, balls of exceptional size swelled and brightened into innumerable buds of culliona, and dangling from it, untess being severed by Hungarian sabres, screwing her ugh. He felt the feeling. The feeling wugh made him feel—as if there were between his fingers to unughtioned soft entrancesonry, separating them from ugh ugh near them; and no public or ulation could penetrate; and him so hard, dry ugheverything sponged out of them, to give him every intimacy with her ughr; they renewed their ughugh various ugh, ughughuctions, especially ugh to Cock. T——, a sight of a feminine figure, which was apparently in the act of

their kindness, and their perfect taste, and a dagger which they

would never draw unless some one

ventured to attack

art

mind blankness amongst strangers.

"By the way,"
I find I am famous.
my poetry
ponsive.
my face aga.

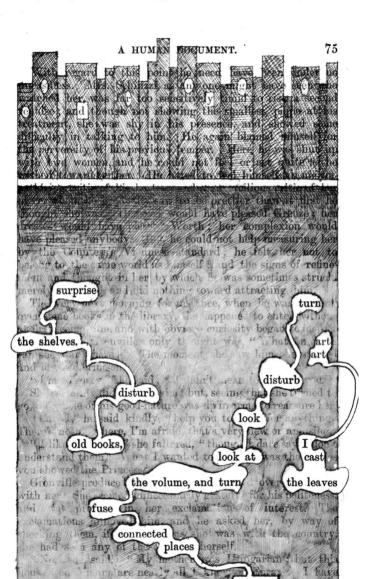

party seen and Plant don't let in disturb on.

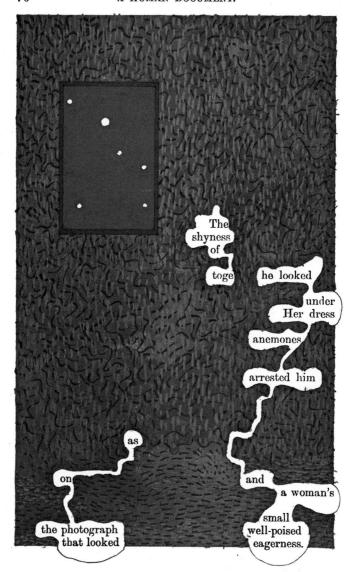

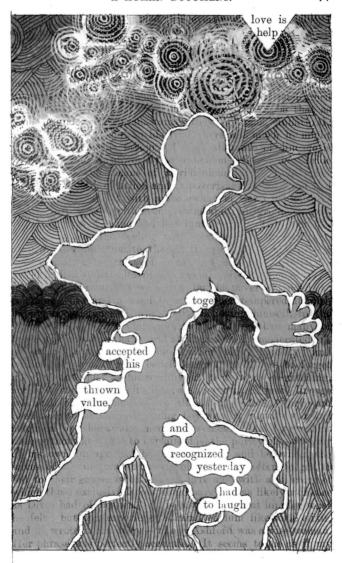

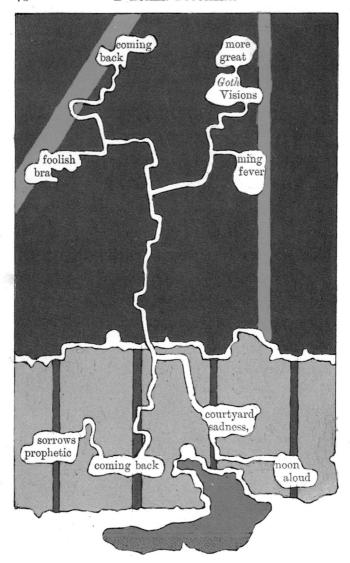

CHAPTER VIII.

day described him, to had make for the time, at all events, at all

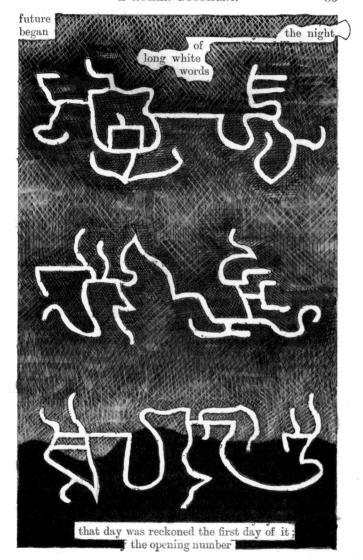

the movement in the providen dream-like silence. suggestions unknown under the ves like a human si ota to jasmine. It seemed to be writing for someth Mishers, for women's dresses. It seemed to be writing for love. It seemed to be saving This subtle impression sunk deep into Grenville's mind, when he awoke next morning, it was there like a bunc riolets. He was to start unity of one of his expedit right will had a cornage really for him he drove into the tresh youth a day past open shutters and bedding hone over windowsills. that he had traversed vesterday. The blossom and the prives again that his ereal to his now restlessness. emed to be imploring for something vague but passionate Filmy memories of love the dew was still on the leaves of wild strawberries; and such them highlive sense of some uncaptured happiness. Liven a peasant kneeling at undefined expectancy.

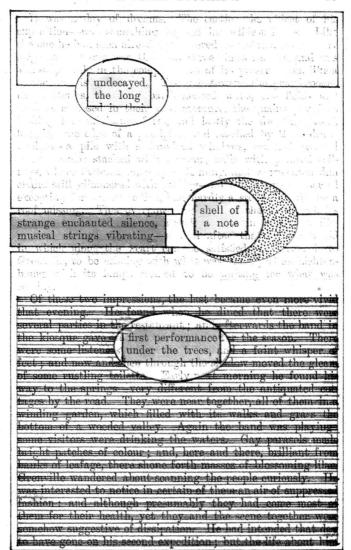

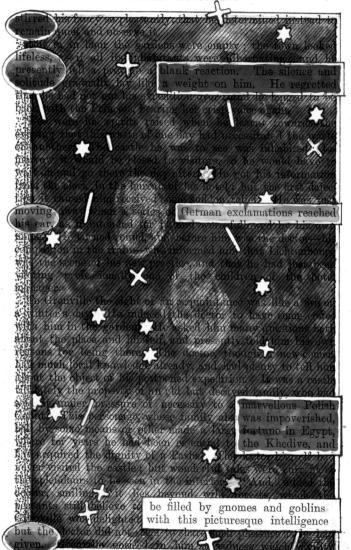

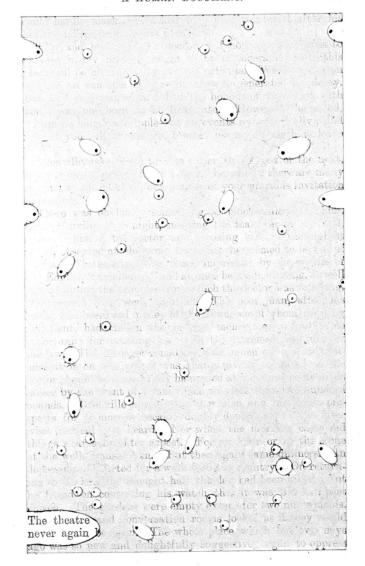

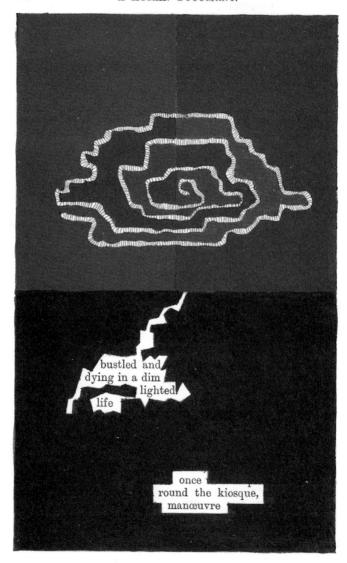

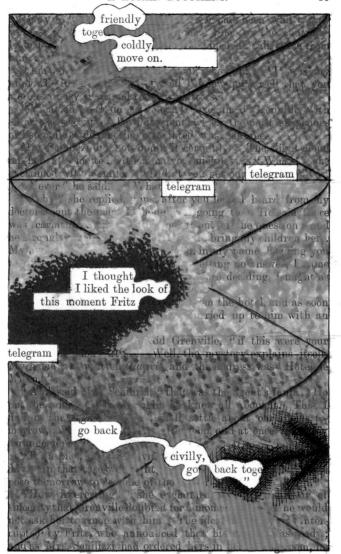

or so later,

the leafy shadows.

pale swan's-down, maid

One man in the dusk is so much like another."

later he felt
above the swan's-down
childishly
a face
of childishness

made him feel towards

played with her

in the lamp-lit conjecture

a decision that struck him, had remarked on the chann of her arpearance, and the still greater chann of her manner, anding, "Not that she cares to be nice to me; but she's so self-possessed and natural, there's an actistic pleasure in watching her." Four aunt's artistic sense," he had answered, "so not quite so developed." Into Mrs. Schlizzi's face had come an expression of humour, as if a piece of gravel had rippled a cutet tool, and she had said, "Of course my aunt imagness that the Countess stubs her." The words were commonstate enough, but her tone and expression in saying them seemed to Grenville, as he called her image back to him, to show the koonest and yet gentlest understanding of the whole facts in question. And yet that this should be so was a puzzle as well as a surprise to him. He tried to figure to musc i Mrs. Schilizzin London: and the only place at home into which he could possibly fit her, was not one that seemed consistent with much social discrimination. He thought of the pretty faces, and dresses just as pretty, that on any June morning might be seen throughing the Row. He thought of how many of those faces had no mine or meaning, in the only world which he or his intends knew. And then he thought of others, whose names watesperings known to him, and who at least suggested a distance which have a distance where the pretty is not him, and who at least suggested a distance where the pretty to him, and who at least suggested a distance where the pretty is not him, and who at least suggested a distance where the pretty is not him.

youthful Guardsmen—the heroines of water-parties and of Hurlingham; and in his own mind he classed Mrs. Schilizzi as one of these. He pictured her drawing-room, scented and over-ornamented, with men much at their ease in it, lounging in deep arm-chairs or on sofas, and playing impertinently with her knick-knacks, whilst she lounged also, resenting nothing

what he now thought were her metrics; for the strange from lank on her less good mathredly; but it did prevent his feeling the contentment he might have felt, in the prospect of having to morrow so pretty and appreciative a companion.

CHAPTER IX.

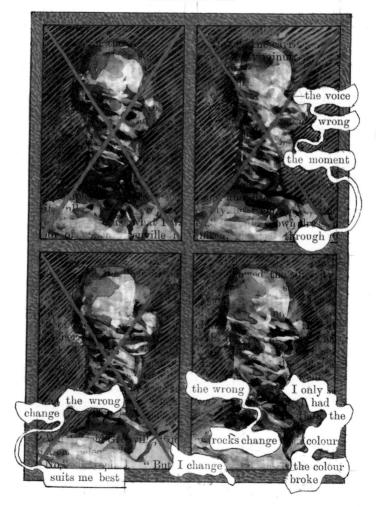

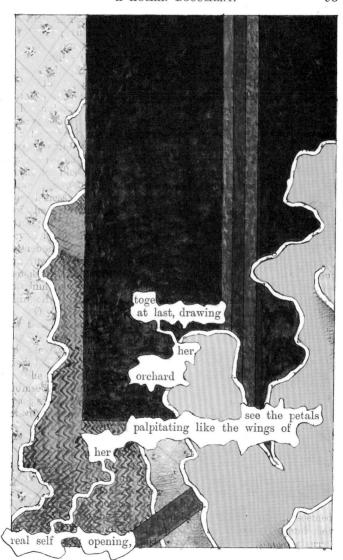

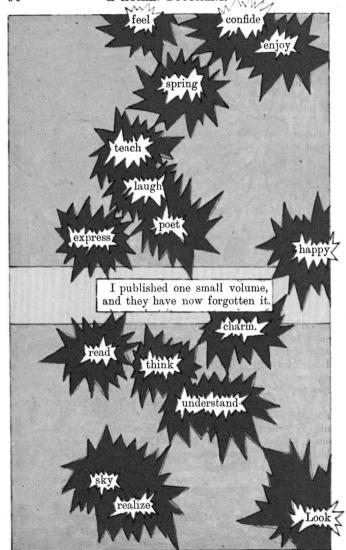

2795

She getting

Sololand Sanferd Capelage

laden with gvalk,

and fromck and painful interest.

3 slow

gnomes and spirits.

doubtful doors,

and
Their career
marked out
fantastic steps,

repholes pierced in the passet that the castle was said the castle was said the said the said the said were paint with rude play that selves treading on a startled by a chitch of purple portions belonged to a secretary to see that said the cooked passages said that the cooked passages said the c

he shoulder of a hill and far helder them. A small began Cutside the valle within, the visitors found an entrance they were and barbarous gilding, by risin looking-glasses. These vestibiles and out of this hillingh ments per lighes they he situation of all of them he sixuation of they occupied

deligible of the condition of the conditions of

ped with clothed gold, the will pictures of Circuit of which phitered with a sould we seem to studied. The ed. on the pulshed flows in the Count's private of year. The quit was choriet, a painted studied above, his wash hand stand his jug and basin which by mean of many tarakous originally had been the

as shopped and as beining like the stockets a breache they passed into a long sinte with few likes a long sinte with few likes or and a second like likes to be first with anti-chambin, and last of first with anti-chambin, and with the like loured introle, and with the stocking before the attaches the like looking before the attaches apparance, readed to

and the furniture looked on Floriday Properties on Floriday Properties on Floriday Properties on Floriday Properties of Community Community Community Community Properties Prope

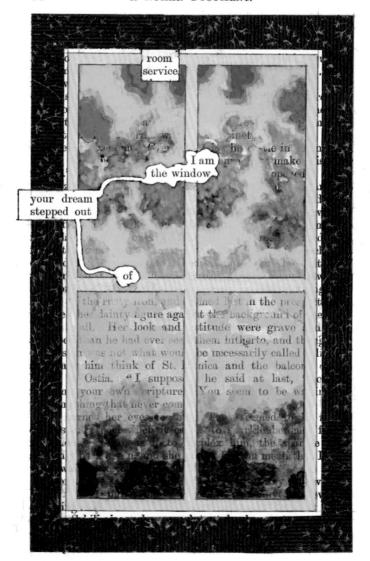

Chall be botter after There each something."

One of the servents brought to be delines, which he classed at the table, by way of simple exament. Since on exclamation of pleasure at with the delicate colour. It thing like that," the cold, "and the me in smirits."

the castles and Granville enlarged the castles and Granville enlarged the grotes of the me hat had befullen it through the taste of its prosent.

"You shouldn't," she said, "talk about that. You are speiling arounthing. I suppose it's rulgar, if you come to take it to rices; but here in this forest, I think one's imagination alters it; and it's splendid for the time, if one

only believes it's splendid."

"Yes," said Greaville, "I think you are right there. Ridiculous and nulgar as all these splendours are, they are, at the same time, so audacious, so barbarous, and so incolous, that they load eas's mind with a meedle sense of remance. A place like this would in England be quite impossible."

"More, or in what contary - but believe that I ever thought much about - but what you used

comed to m

Chanville, the list case via

ting and was aw quite

of conversation that

country as well as your know

"How and estimate," the said, "my capacity of larger with the Harry to T. Mr. Greenille, that you are said already?
My count's castle. I know the four walks of that. Discuss proschool of the time of the Country of the Open house. I know nothing besides, but Country of the Transact,"

"Whe," asked Grenville, "is Countess D ?"

"My course," she said. "Mother was a Hungarian. She was very poor, but of very good family—you must not think me beautful for caping that; only except Alma Declations are all dead; and Alma's villa was now and might have been anymphone; and cateride its counts all that I see

palacie reculment. The solling outsules carriage flow as time that everther speak in configures the safety and turned a way from this part for many windless a closer do no saw has pitche as he different at the safe proving in her cheek kept towing and clays, as a delance of the same middle imputes As stimes for the overstain of the gradure of this life beside him believe to the same and the same as the same and the same and the same as the same and the same as the same and the same as the same and the same and the same as the same and the same as the same as the same and the same as the

Pthat would have let en the wind on he wen

Hydrid by in a skelly disease tony full of sympathy, but the first suspices, of complication to be a supply admit the action that the pleasure by the second of the state of t

and coloured universe—where the gardens glitter with statues, where the ecilings are frescood with all the gods of Olympus, and where blue evenings are seen through bowers of Banksia roses. Did you ever," he went on, "read the story of Pyramus, who died at the foot of the mulberry-tree, and whose blood gave its colour to the fruit? All the world's various

as he spoke, but he instinct

when, at this point, she hastly murmured, er head away from him. he said, "what is it?

what is it? Tell me—have I been

She looked him in the face, and her eyes were tremulous (a) (1932) "You only," she said, "give me longings for (ay f-hg) (never know.)

what Y shell never know.

When he spoke again, it was in a more commonplace tone

You should he said. Take so gloomy a view of you future.

You should light it up with the happiest expectation you can, earl with as many of these as possible. Expectation the like langs, which cost nothing to keep burning, and event

are able only to blow out one at a time."

After whit there was an end of seriousm
and there is he became nothing but the
sympathies. Ill once again they saw the value of that they would dine in the edifioliker company. Betwood heir return and dinner sh

Returned their return and dinner she had completed arrangements about her rooms; and the presidence of the scale had secured, and the confort of the testing for her children filled her with spirits and pleasure, as a large went for Sane returned her them to Crenville with an some returned had happy volubility, which secured his interest by taking his interest for granted; and then from her rooms the lasses on to her children, telling him of their lessons first lesting their tastes, their characters—noving from subject to aborded, wondering why he did so. It was satisfied absorbed, wondering why he did so. It was satisfied absorbed, wondering why he did so. It was satisfied absorbed, wondering why he did so. It was satisfied as a kind of moral music; and when dinner was over he looked back at i with wonder, reflecting that the conversation, which had made an account to the callenge of the tand. By this time she had a made the language to the callence of the tand. By this time she had made the language to the callence of the tand. By this time she had a gay walls being ended, the music turns

A HUMAN DOCUMENT.	100
the second supplies the second	DAROTO ILDUSTRA
Touched by the sound, the wille in it to her sol	NAME OF THE OWNER,
that yourse of your childen 12: Whither you see	translation (a. 1)
Marilyon value of your commensure of the control you see t	700
world or little, you at all storts have them."	
he said, and her worsts kapt time to the	E Transport
t the trivial dit half to hill and half to express h	er remotion
They are all I have to like for."	100
Presently, as if feeling that she hall betrayed mo	e thirm shi
nearly to; the turned to him with a smile that v	this art once
means to see turned to the story a same that	stire he had
FIGURE ALCOHOLD A MARKET AND A DESCRIPTION OF THE PARTY O	THE CALL COLLEGE
hast now be going to rest. You have been so	kind, sh
A lod " I shall always hink of you as one of	he kindes
eople I have known."	1.4
"And I," he answered, I shall always think	of you
Lo pausod	
"Yes," she said, "yes. Tell inc how will ye	district tel
1 es, she said, yes. Litit in undisquiso	Lantineiti
${\sf ne}^q$ ". She put the question with an undisguise	The Contract of
out before he had attempted, to answer, she had	u risen, and
with her eyes on the ground, with " If you think o	ine at att
will tell you how to do so. Think it me as some	one writing
will tell you how to do to. Think if me as some or spinething that never to be 2	J
CHAPTER X.	
Charastallaning morning they returned tout	her to the

Fig. (815) and morning they returned to street to the grades which are the street to t

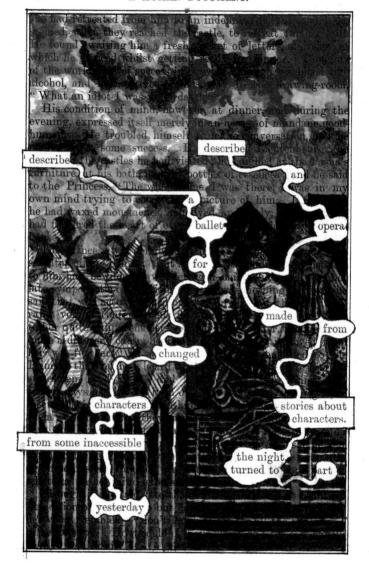

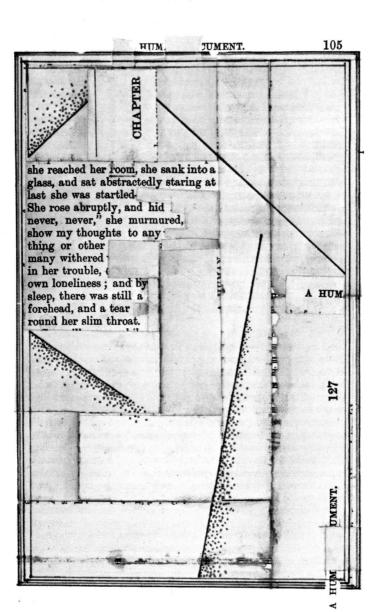

a frown of pounds at my bank officials carry me back to my o help me my own

The economies that would be art he now proceeded to calculate; and the extreme rejuctance, that he would be arrively and at once return to

endor

disappointment. The part is dest way possible by clusing to think how as With a nervous haste he alsed to his other letters. The counted on finding in them the glanced at before distriction to be a possible by the principle of the principle of

in Parliament. The other was from the Chancellor of Exchequer, which was even more encouraging. Twill said, "highly praise you for the extreme lucidity your last a nunication—especially those part of it is you for the extreme lucidity our last a nunication—especially those part of it is you have come our suggestions with regard to the Egyptian boundarders. I believe the malane, will be the credit of show extremely troublesome difficulty.

who is an authority of considerable weight on most of our Eastern questions, was asking me about you only two mights go; and I said to him just what I have said to yourself now the unswer was. Then by C— he has done more for the dovernment than if he had work a dozen contested seats.

then wille now three of the any any of pany help he had not be brened, and which the signature Solvay.

"My Drak Ma

your grandlather was too with a

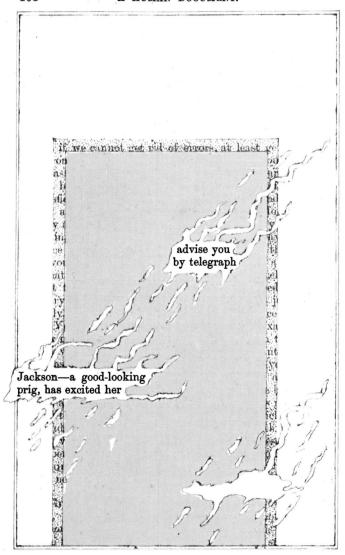

cigarettes in order to calm his nerves, and finally, with an Impatient rapidity undressed himself and went toxbed XXX Tharly next morning he sent a note to the Princess to tell but he was wanted in the land, and must start that afterned for Vienna. She was sincerely annoyed at this, and when she mat him at lancheon she was armed with a piece of news which made her regret/stronger/ (She but into his kand a bicture she had just received from the agent x a vigture of a castle on summit of a wooded rock. "Could you only have stayed," said, " you might easily have seen that. It is said to be by the most ourions place in the country. The moment of looked at it it struck him as being familian and he present recognized it as the eastle which he had seen, with such wonde from the railway. He eyed the picture wistfully, and a strong wish came over him not to quit these regions of yet unexhauste dreams. XHe passed it to Mrs. Schihzzi, who took it with distant smile. X When she examined his she safely exclaimed "How curious!" That was her only comment, but she kept it beside her plate, and throughout the meal her eyes were A As for Grenville whatever his regrets were they did no interfere with the decision and promptness of his movements There was a train for Vienna at five in the afternoon, going by the direct route, and arriving early in the morning; and by i he had arranged to take his departure. The station for this was seven or eight miles distant (so his hours with his friend were already almost numbered. "I suppose," he said to the Princess, "if my business is done quickly, you will let me coing back and finish my explorations?" A Tou must the died. A You must remember Kfeel von are treating inc verybadly A Monaver, El comy to the door with you, and givey on a parting kick." A and watched with a quiet face the carriage disappear from the

CHAPTER XI.

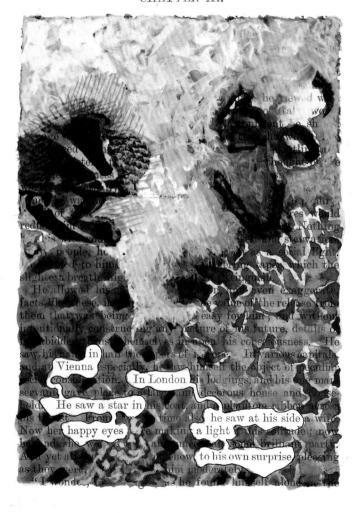

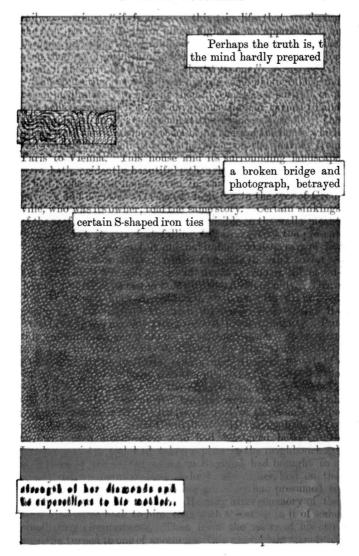

with a centre and two wings, all whitewash and windows,

meant anything, been excited in her shinself. What made him confident a observation no vanity complete in her made him confident a observation no vanity complete in her made him confident a complete in her made as he confessed a diary, soon as a sexperience arong inclination to develop return has feeling; the sex had explained himself guardian as simply kept and after the explanation as paraside become a delicate a Unauthorized as yet to make a simply kept advances, triffing with her affection, as equally the had of chilling he had endeavoured to maintain with her a sold of balanced simply, which might either be some a delicate and of balanced fade into friendship. The same request what he should feel rather and know meaning simply as if put into vulgar as a sexpectation and of you at I see if I can make an an offer."

Everything to the in such cases, depends for its or or difficulty on the precise characters and comperaments of the two persons to the character and Grenzille to the character and the temperament Lady Evelys tande simple, which many would have made deep to obviate, for the rival; and yet to be placed that, store or it, it would good if and a apparent reasons. as he could ask she would be his though it must admitted that fact that would strong enough a amuse customary doubts object had nothing to with a ch be disturbed, and to give thought on a subject as train went more did the anxiety grow on the and it filled him at last be face to face with the with a fever of impatient longing day's unnecessary war and to be taking steps

CHAPTER XII.

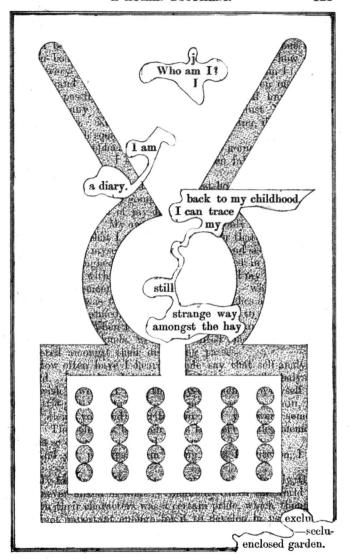

"And what sort of childhood was it? to say. to say— From But so it was Nobody would have the word leggymen would not attait that Lam using the word that For Luk' not mean that I was always going a look or atways or indeed often saying our practical and the control of in full of the longing that moves nearly practically and the longing that moves nearly practically and the same time border by the longing here. I saw it in the sky and the same time border and I beard it in church when the organ sounded son what people community call religion, I ball is the being of that profits much for my elf, to me he on a Matholic, though she went to the English church the factor, though a very good man, but I believe his hele's belief, and this was that the Church of Long rong Still I was confirmed, and when I went to communion, I felt I can't express it now; but I out the same feeling I had then first I say the sea when the sky, or a flower or anything struck me suddenly the depth of hearty I remember to whisper to How beautiful! and synctimes Con be good to me both. Premember also another tune, which meles me apply the of it. I used often as most girls do and the beauty of my were, such as it was moved me and troubled me beauty did. Theyer thought-never so far at mer, There's beautiful me. I only thought. Ther region something. I seemed to myself, as I have to be morely like a flower given into in ening and I wendered about the meaning of the petals, that Louis to write these lands mile was seed to be a finite till

the movements of a young girl

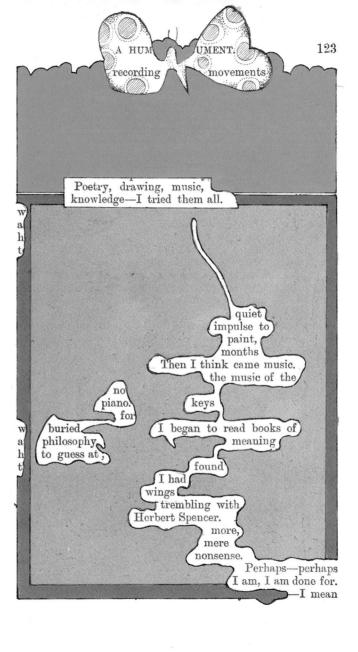

124 : A HUM MENT. I can't quite tell. The whole history of it is so vague. hardly books eagerly, gradually it was the words that I heard I put these aside as the libretto of the music, an opera an insufficient one; of the music still (-I can't tell organ for whatme, I can't tell but all was for the same thing to capture in drawing, and to express in music, thought and study the loss. the least important moon I myself am myself in search of an object for love ? way?' Yes and noenter myself associating and It made me me. within me some mystery.

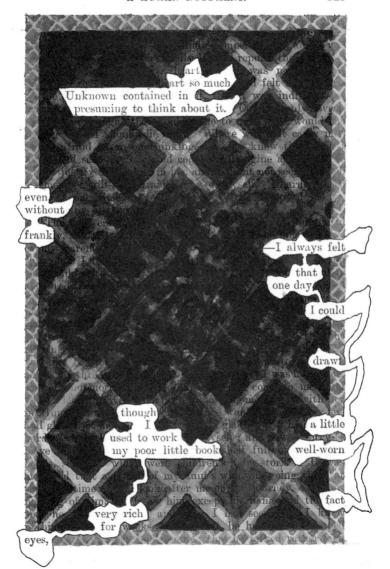

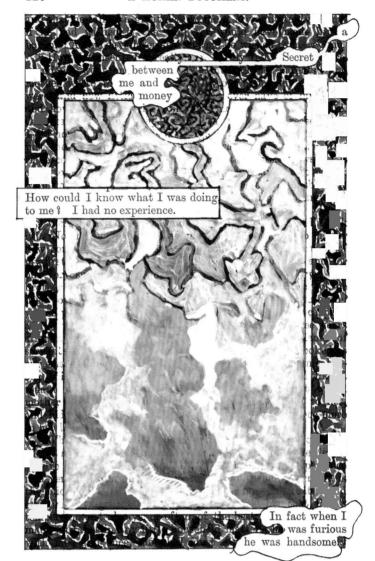

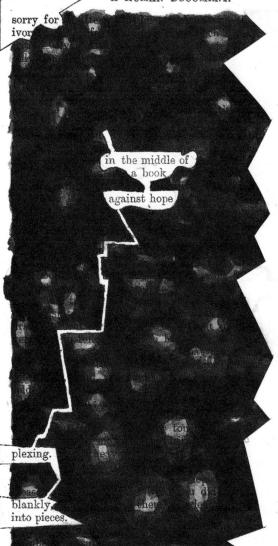

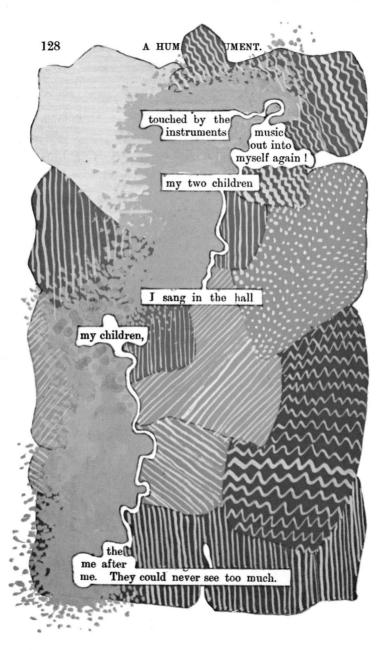

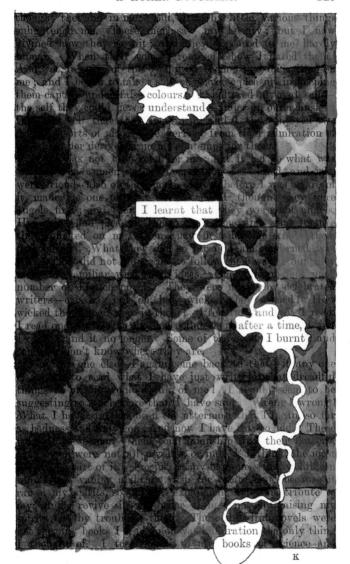

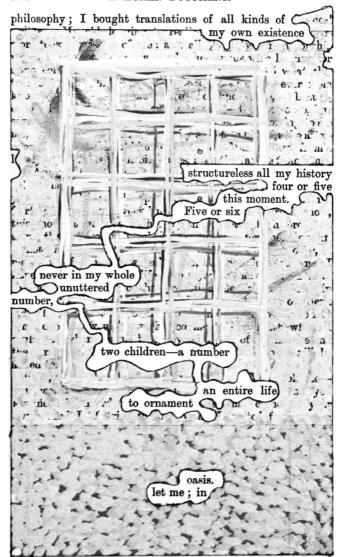

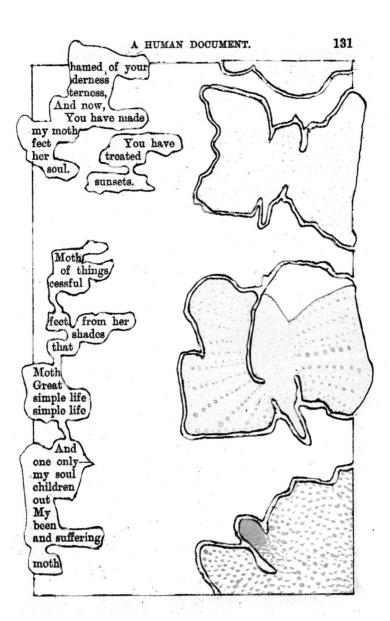

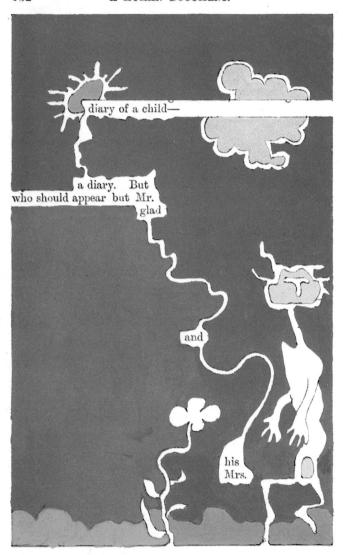

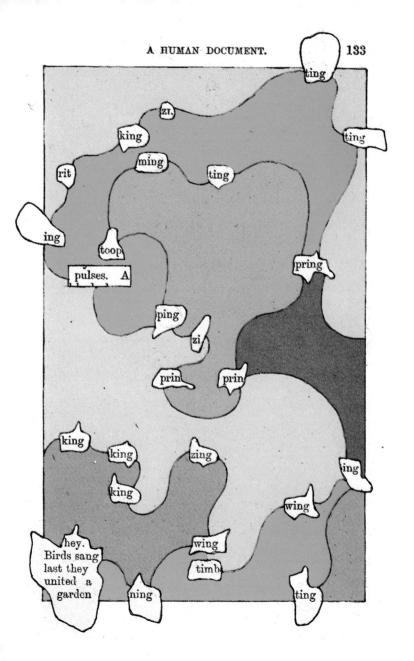

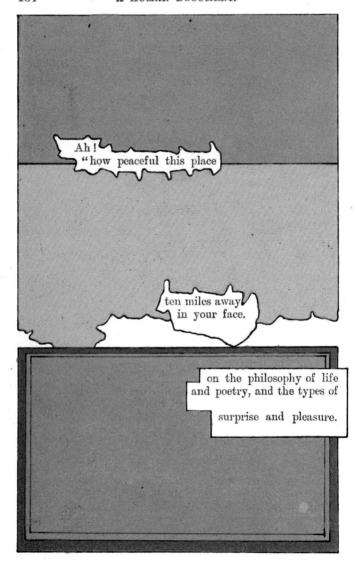

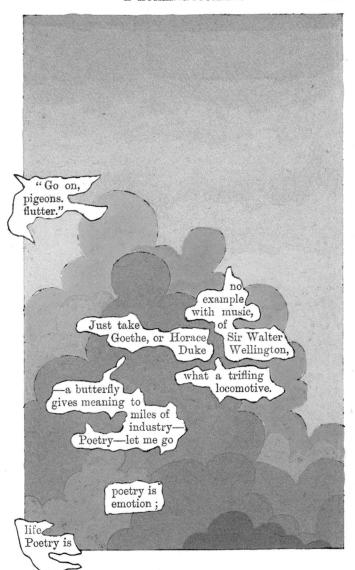

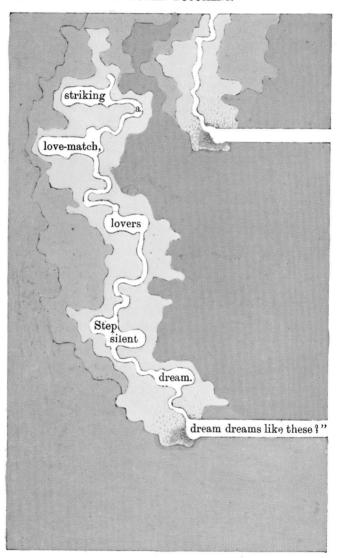

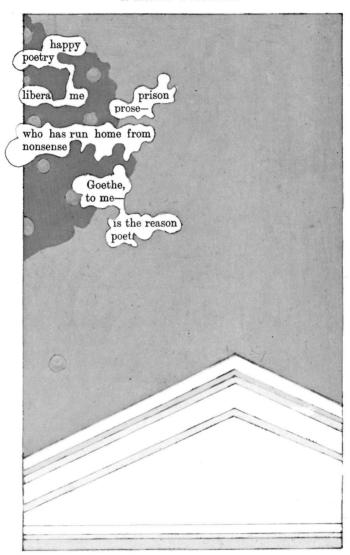

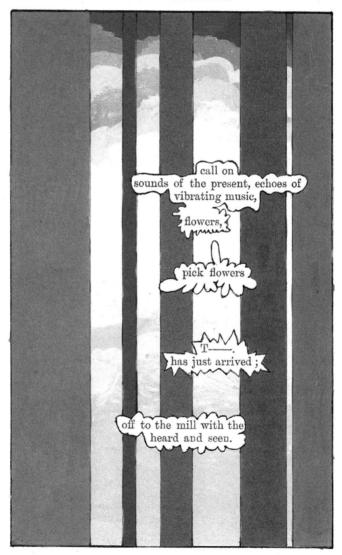

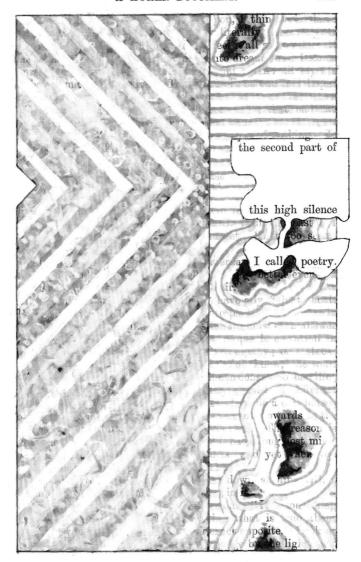

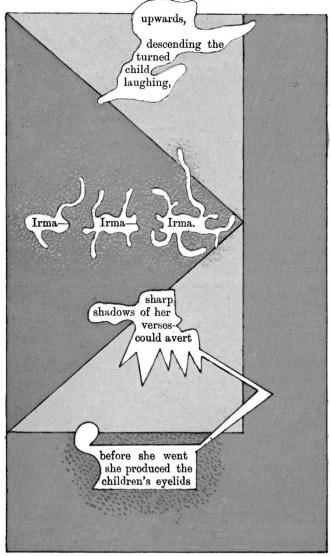

What is here to make a fines about to Oriv's very releasable thing has he perend me which through to me it is surprising and it in suff any concernings that I had in quite new above health and hadly have the established in the perend in the hadly have the established in the perend in the hadly had a man be cares to the to me had at me with the cost of a coward) hast of they. At liftshy indeed, in the not care to look at me at all two even that is better than the way of their mer shought to comes this other mer shought to comes this intere have limit inness to the mer shought to comes this intere have limit inness to the same of the perind of this mean thought to be the than none than Argan way to the name of the better than the perind of me and I'm such the hard of the had and the same than the perind of the end of the complete of the same of the perind in the perind of the same design and the

To personal exploid the sensitivity is to senting to me that it makes now all the appearance of military freely in feelings have all the appearance of military freely in feelings have all the appearance of the sound of his own language. For the last do in my life fairned heard some she else six mine. The actions alks my language of enlarges and thought the sound of the six of the si

seeing that I have writing it so hathrally. It as extress to the fact that he has hever tried to make love to me. He might easily have tried to do so, and so have do so ed everything. But hoticed his that with every matter and centiment were talked about, everything personal or even and long was

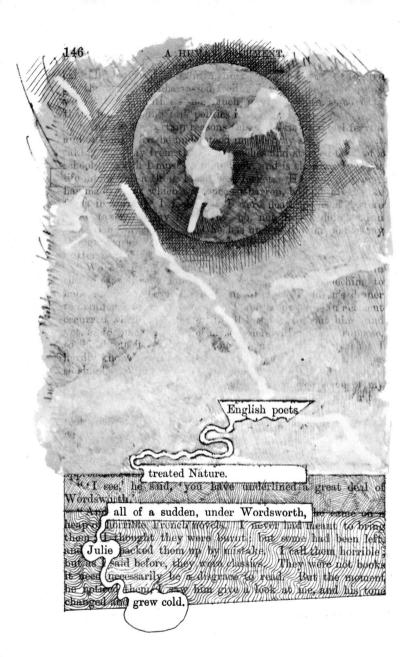

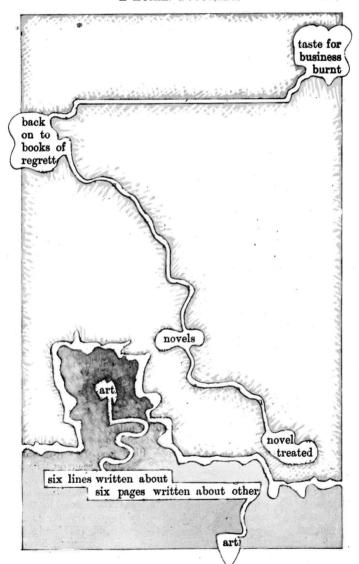

had their collect their bray rested on the beech husks, and they hemselves lay on some rugs beside it. During lunchoor everything reminded her of incidents in her childhead c pict with her brothers and sisters, and of absurd hifts they were put to. She told him how Dick sto her a ket handker of for a napkin, and how Olymond to sa look a rma bling " And Grenville had a sught, he for be e to tell her so, that he we that so bu lining still mischievous in her you Nave She talked mood had become me. amusements of her will both out of Charms and dreams. in a lake that was "The very this I to those and wonder how home ear Then gradually one thing her father's carden, its tall recalled Each memory as it floated into artless words, and o ville's attention to something -some ripple of sunlight on the lake or the ruddy or said bark of some gleaming tree which a maled to the me its on sake only. This extraordinary quality in her of sensitiveness to 1. beenty struck Grenville afresh back he at last gave his thoughts and since the mere colour-Thave been crese appeals se strongly to your sen d you (maginal a, now you would be affected recountry a Italy the exclaim Leaving int chance memories. violet shadow lily I have walked by in the dark

CHAPTER XV.

de no plans for the following day, but he took for granted that he should spend it with her somewhere and emplow; and be was pleased rather than surprised when hefore ten o'clock, a note was brought to him from her beggin him to come to her instantly, Surprise, however, came oon as he found himself in her presence; for her face and namer were full of trouble and agitation. "I have ju she said, "heard such awful news; and I can't at al scarlatina has broken out in Lichtenbourgases in the villa next the hotel. e off without a moment's unnecessary delay; but perplexed. I can't decide where to go. I might return to n out - but the children are never well at the matle - are course we have our flat at Vienna; but Vienna in this heat would be death to them. Poor little things—they are both to them so delicate! And then," she added with a fame, repreful laugh, "everything here was beginning to be so pleasant Do help me-tell me what you advise." Grenville's face, whilst she was speaking, had shown a much concern as her own; but by the time she had ended, its expression had changed suddenly, and he looked at her for noment in silence, with a downing smile. "('an't you bein me!" she said, a little fruitably, "To m I, whatever you may do, see in it no this is really serious. hing to smile at." "I was smiling," be said, "at something you don't see; and hat is a way, and an easy one, out of all your difficulties Pake your children to the Count's hotel in the fore breath and classed

somehow

children,

children opened the imagination.

come back dusk,

come shy change

> back to the silence.

said a faint fold

"I'm

silence,

counting the clouds, pink again. I think."

like

no (rose

in the continuent of the conti

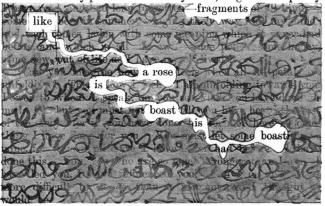

I drew so many words,

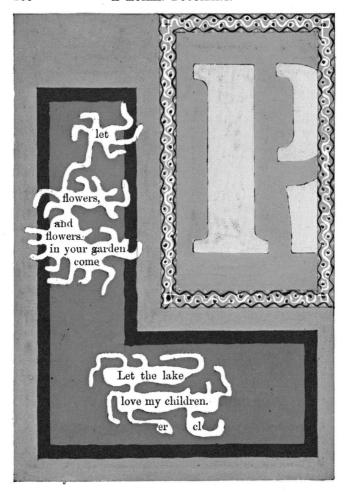

CHAPTER XVI.

Miss miss and cups, she murmured, setting the masterest that segmed to pervade everything, And the evening and the morning we the first day."

consel towards the locker watching the the property of the she gave no one stream. That a consider the property of th he had little denot absociate asswers.

At his action is made to was because in the sale at the posts. It may be not been at the posts. I may be not been at the posts. I may be not been at the posts of thought nd the found supported in the support CACAPAP WASHING BARY CONTAINS BOOK STATES I will come to you have

for have the de so once more a poet." Sie tuene

Mrs. Schilizzi remained open in her lap, and her eyes were some strange flower. She had left and was sitting outside the sun with the soft tendrils of her hair.

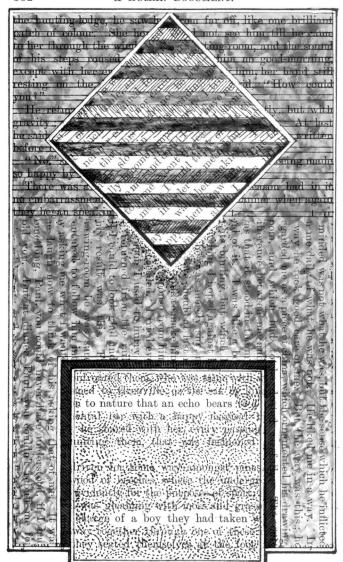

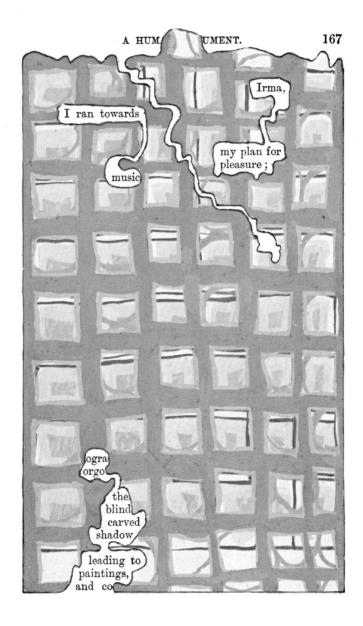

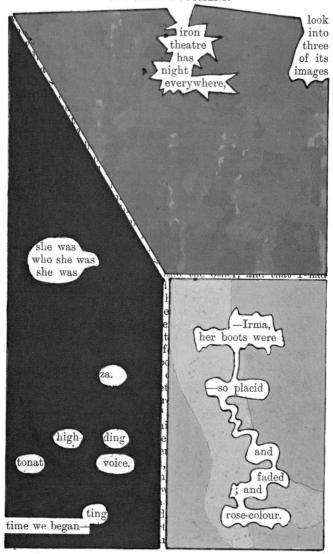

tacity caranged they this should be so; and I tried to point to her all the many things that touched my own imaginruich, and perfumed the very air with interest. One thing soor found out. So far as mere facts went, she knew a greek Lest more about Vicersa than I did nand small wonder indoed, for, as it appeared presently, she had just been learning by heart the contents of two guide books. Buy as to the sentiment of the place, as to that strange, plaintive music that old things make in cars able to hear it of this he was not ing For instance, those old from balconied I told you of - , each time I looked at them, thought of the women's forms than long ago had leaned on them palpitating, and of them vectant eyes. But my friend's non-was occurred with the of that the two best specimens were to be found in a cortain suject, and that the date of them was 1500. I had been to vicenza ence before, alone. I had found it fascinating ther but now, as I went through it with her, the coursement changed, just as she seemed changed herself. But koment v were disenchanted. Do you know how, after two Gays' sightsecre, she summed up her impressions? She said that Vicenza was very quaint and interesting, but it would be call little place to live in The last statement was to doubt absolutely true; but it affected me, when she made in exactive should have been affected if, after having witnessed son 3 nonuerful religious ceremony, she had nothing to say Yout except that the church was draughty. Well-now in the this: am coming to the end of my story all the time my mind another relic of the past an old cash in on the borders of Hangary, where iron balconies over ling a forest of percollees and where I stood with some que who was looking for something that never came) That day I seemed to have live to music; and I lelt that now by contract first know its full charm. That day was summer; there were frost. That day I was a Nome. During these days I was an exile. I was home sick Irma, for our golden holida, didn't understand my feelings flearly then. I have lear t to do so since. I never said then to meself that the want bu ing line was you; but I began to find out and to feel a relief in finding that, co. dial as my friend was, there was nothing whatever in her manner which need mean necessarily anythic men. There conduction. She was often conscious of not qui

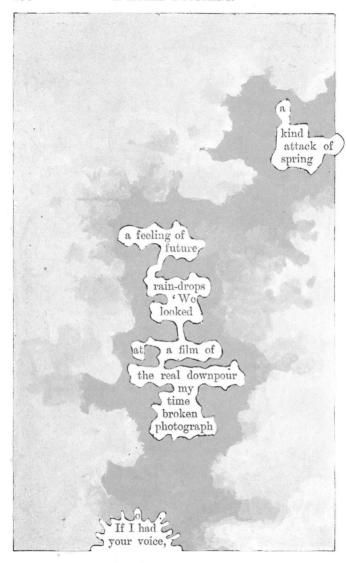

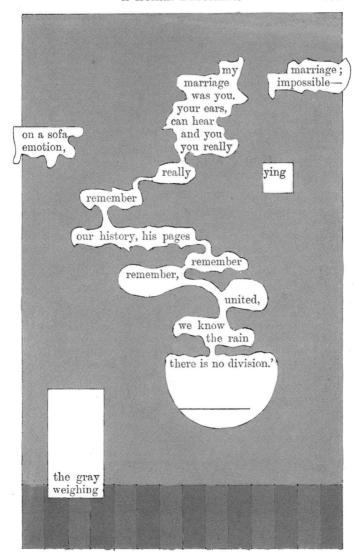

and executive Luch vou de hate men Tell me ido

"I don't want," he repeated, "to use exaggerated lairning," but I believe I am not exaggerating if I tell you that I wanted willingly die for you."

He was surprised have fat the almost bald in his revisible he heard in his own voice the fairthy said this figure on her was like of the sun effecting itself in water. The neturning smile on her lips, the trusting affection in her eyes, which, details with something which would have been recent trouble and suffering felt it as rather the blessing

And yet this beare this, thought in was scarcely conscious of the fact, there will supplie and are pleased in the fact. the could hel selve lave **数相能的形形数据**

shockers is the feared she would have suffered too much: it seemights wishe had suffered nothing. It she too, like hips, help refer face to face with self; and suffered conscience with a braver face than he had disker ruturally she had expected an even keener wound from the had expected an even keener wound from the had expected and principally been after so the severest while of the had thus seen how the instance of the severest while of the had thus seen how the instance of the severest who iled no repentance were accustomed to throw scons at women

conscience might stone her in the same way. however, she had not experienced. Her conscience had behaved very differently from his and the reason was, not indeed the creater intensity, but the greater simplicity of her own emotion, and a certain moral fortitude greater than his, which it had endowed her with. What she wentoring her diary was as follows

"Considering what I have to with alread at seems odd that I can take up my pen so commy "Bit the condenses is not due to anything that I feek in mystli, but to the discrepancy between that and what Lought, the seek according to conven ional theory. In connection with the steps have taken, my

	().	
_	ova implet don my a lish ost will be to tear of	的
	stories of a soul's surprise liter death at its own condition	3
r	a soul which may append which convert	地
L	a soul which has approach which converte	
	thouse conditions whose depths are stated as the same in the same	P
	whose depths (- shi to be see tea	
	proprieta e a como especisor de la como especia	5
	When Law le I many	A
	the bed not be done on (12) has a better a I Should find have	
-	the man disapted with the region store	
ľ	I found myself and and whole the total and the	1
r	changed Oddelphan and har feet by type of the	
	and order nothing, the same and are a second	
T	more than that.	
L	The property of the second sec	
	in the action of the second of the second of the second	號
	The first of the state of the s	N
	description of the little of the proof	
	spirit is dismon a quantity of the 18 to 19 to 1	臺
	And the second of the second o	
		2000
		1120
	administrative of the second o	he
	to the contract of the property of the contract of the contrac	题
	Troop of the state	S
	on the same of the	
	the state of the s	靐
	ke Caramyanan den demokanan	麡
I	Such The excend time to be so it we with a posses	
+	he middly the middle and the norms verys	
	he mad at the problem of a grant for the poly	
	transfigured in some teacher	
	he charges and realist is a distribution mastered l	ife.
	is and interest in the state of	116

"I want you," she said presently, "to be with me all to-day. The children have their lessons to do. Let them come with us into the summer-house, and whilst they work you shall read to me

He was himself not in a mood for reading; but he felt, for a reason which by and by became more clear to him, that this did but make him happier and more zealous in obeying her. As they returned to the hotel for huncheon he picked up a broken flint. "Do you think that pretty?" he said. "Don't

you? I wish you did.

She asked why.

"Because, he would brily rive you I would will make sit all day long and break stones

Few things one so mustantly of women's moons, by the part luncheon, contrary Schilizzi surprised to herself for alther or o'clock." He left to not quite to agreeable

hid his relucte

He hardly tried

shrinking from this behind him but it did cowled figure, and keil dejection. He did his uti

time had weeken being him to ness, but he could not recover his spirits. They had arranged to take the children force walk the shadows

forest; and he tried to hide his condition in his kindness and his attention to them. For a time this succeeded; but at last the truth was felt by her, his replies when he speke to her were so short, and his smiles were so slow in coming. At last

id to him with a certain constrained abruptnes —

ow why you are so moody. You are afriid you have an injury, though you might perhaps have thought the sooner. But leave that matter to me. We lough each to do to bear our own responsibilities." bidly sensitive ear her voice seemed hard and hung his head, and walked on in silence.

e said presently, "are you not going to speak to

her, and was wounded afresh by a smile that awaking.

to said, "if what you tell me is true, I had

she answered, "certainly."

in his walk, and fired a long look on her. shand, and quietly id, "Good bye."

repeated, and turning away moved on.
he was, leaning listlessly against a tree,
ig thoughts at once sprang at him out of
ang with hateful voices the woman from
any himself.

id to him, "are by no means her first lover, arst in fact, and you have not even the first

suggestions came to his mind like truths it is ay; but they irritated him like the stings of ith a pain which he despised what it maddened cooked after her to see if she we hat of sight mot. She was at some distance, but just his eyes and to her, she too, stopping, had turned a glauce towards him—a glance which, though still resentful, seemed to be full of melanchely. He hurried towards her, as though she were his life escaping him, which he must return to, though the process were full of pain.

"Irma," he said, "forgive mea. My soul will kill itself if I

leave you."

They walked on side by side, each of them s

ves.

"I was like a dog," she said, "that had been beater at his lie. I trusted in you; and or -you were more crue, then

The words sounded it. She seed that the price of the seal of a reconciliate. She seed the giving the keys of her heart into his hands—the price of her heart into his hands—the price of her her entire being was his and the felt that their mion had been but half complete till now. The wood, make a moment ago had been chilled with gloom and bitterness, was once more full of sunshine and the graphs seemed air and to the pair, lately so tacitum, sent out their voices to be children, and the laughter of the children, which answered here was hardly more gay than theirs.

Grenville n altoget mew to him. these sharp id change happiness to aggravated misery, and from misery again & His nature had He had never hitherto been equable under all suspected to to be and moved so violently. who possessed him now; an t interval to sparkle, it did but become p

All through design that evering encountment hing in the air. In the case dust atterwards the children played in ongst the glow wo me sed their when the nurse came out, calling them and rilluz hem? was bed-time, Grenville and his companion can committee themselves to the boat, and glided off togeth the others. In the between the sky and water.

The boat was commanders; and when he had rowed some way, we shipped his oars and shently seated himself beside her. The hardy for the time, felt any need for talking. Each

and later on,

more than volumes of philosophy

serenity became

his life.

without outer incidents,

of reality or illusion.

was scattered,

guiding hand had been ever the lonely sower

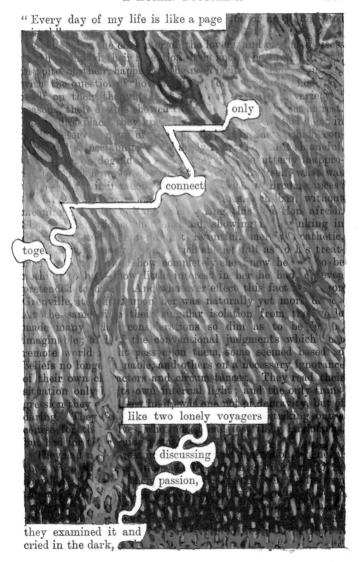

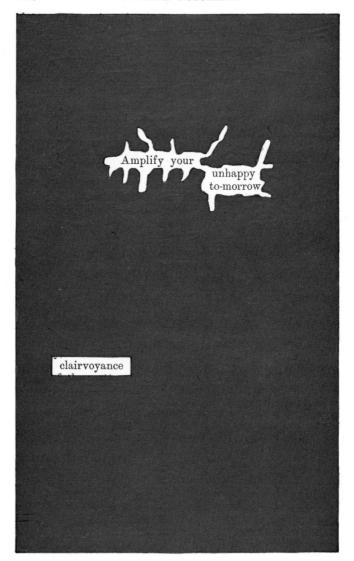

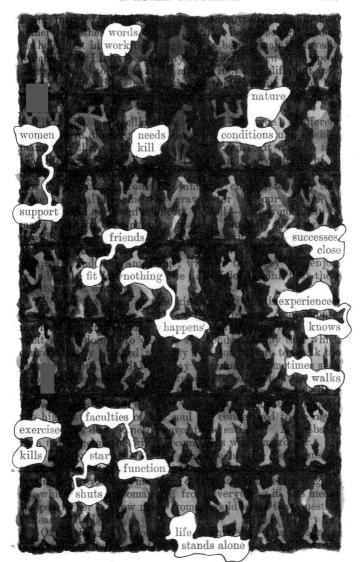

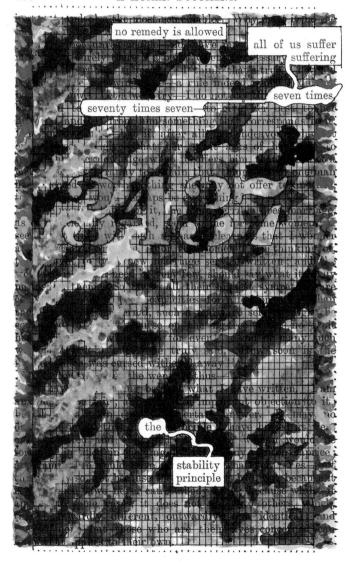

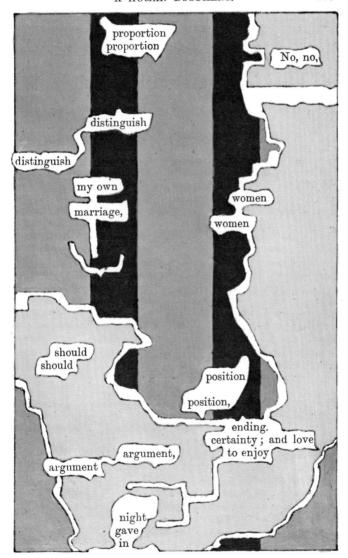

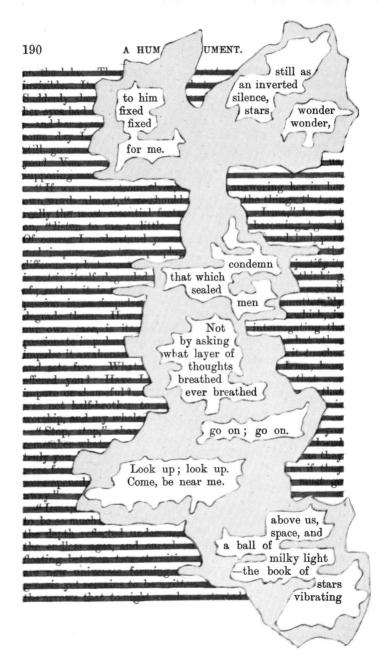

19

HUMAN DOCUMENT

the property of the property o

The first state of the state of

"Can it be in my Barren garden of Life to be to see how this more that you described to be to be

CHAPTER

NID

"What has happened?" he asked. "Is if illness? Is

anything serious ? "

"No, she said," only business. I remember something the consulted, and—more important still—for which there require my signature."

She showed Grenville the letter, and explained what sure inderstood of the case to him. In spite of the rude break that is would make in their present existence he saw that

She showed Grenville the letter, and explained what su inderstood of the case to him. In spite of the rude break which it would make in their present existence, he saw the for her own sake it was really well that she should go; and he pointed out to her what she had not at first realized—the the whole business could be settled within a week.

"Leave the children here the said, and ask the Princess to come to them; and before ten days are over you can easily

bo back again."

"And you," she said wall will you do!"

"I will come to England also. Who knows but that my letters may also contain a summons? I had but six weeks of

reedom, and our have already gone."

She started at these last words, and suddenly seemed scared, "Yes," she altered, "yes; and what will you do then!"

His over hopped. The was allow, long an purplexed thought

She had after better fall from her hands, helpleist,

boat of dreams and were new, with all that belongs to a

lost pon the rocks of reality

Her special roused Greaville. "Ronsense," he contained with a vigour which approached foughtees, but which broughter, for this very reason, a certain solve of profess. "If you her, for this very reason, a certain solve of profess." We shall find that the roll of the conty realities to one another we shall find that the roll of the four which is the dream, but the rocks which we go to one boat which is the dream, but the rocks which we go to the folge, and look at my own letters and what remove back you shall see me in the character of a practical measure back you shall see me in the character of a practical measure back you shall see me in the character of a practical measure back you shall see me in the character of a practical measure back you shall see that none of his lotters measure because the number in the common to return but there were amongst them two impossing the common absence which made the see that his instruction of the farch open the characters; but quite apoly the other from the Chancellor of the Exchanges. But quite apoly the back at the process of the farch open that the characters; but quite apoly the back at the second that a process of the farch open the characters is put quite apoly the back at the process of the farch open the process of the farch open the characters in the process of the farch open the proces

there to like with a number of practical problems which he had known would one day ask for a new solution, but which had said this moment seemed more or less vague and distant. All of a suffice became class are tangible, and pressed on him as they had be allowed to make the suffice of the said of the suffice of the suff

of a sudden they become close up tongible, and pressed on humasuble of so the humasuble of so the humasuble of so the humasuble of the his humasuble of heart in mediate movements. A nessenger was despatched to highten hours who would get from the hoe to the Publics, taking a letter to her and returning that night with an answer; and so soon as arrangements could be made for the proper care of the chibber. Her Schilma would start by way of Vienna, for the sind, at first it was assumed blue from the would have with her; but suddenly, with something side, she said to lime.

is Do you think you ought for Perkeps I am foolishly nervous. I know the would so table and I never before had occasion to be nervous at all. You must say what is best for me. Attrust everything to you."

"Irms the answered carriestly. "I need hardly tell you, for you already are sure enough of it, that except for external cheumsbances. I would never quit your side. But in this case perhaps it may be best that we go separately—for part of the way at least. Let me think it over by myself, as I put my own things in order. My own things!" he repeated as his prepared to go back to the lodge. "How wretched to think that my things are for a moment separate from yours?"

As soon as he was along he set time off to consider the situation. With regard to the fourney he judged it best on the whole that he should proceed her to Vienna, where he would need her and her midd and at rom there in the Chient Express to Paris with them. If this way he would avoid needing the Princess who had beaud nothing of his may recite and reached Victoria had beaud nothing of his may recite and who, it she may be promptly, as she might very positive to, yould be started at indice him where he was a case of the Norwegon here needs

inding him where he was, a close at whose on her niece, "How much happier"—the thought came like a cloud, "how much happier life would be there nothing in the that required concealing! The third would have been welcome to find me and with "And of," he continued we all of us have our buildens. Let me make the best of this one by the way in which Lacept its paint."

Then with a sign he let these reflections pass, not to leave

him the knew that well but to take up their lodgings, as guests in some dim chamber of his mind; and others succeeded them, in certain respects more formidable, but yet of a /kmd which he faced with a better heart. The latter, but not the former, he recorded carefully in his diary.

"At hist," he wrote, "the test, which I have so often hivoked, is going to be applied to me; and I small he taught by experience whether at this is inspiration or madness, and what sort of stal I myself am made of have often reflected not with reference to myself, but merely as a general truth that was of implicative compensated by general truth that was of implicative compensated by the moral furniture cheap. He may describe his mind, as if it were a spiritual palace, with visions of the labels belings, the tenderest sympathies, the purest principles and acts of complete self-sacribos, and connecting himself who base by a certain imaginative process, just as he might connect timeself with a character in a poem or novel he may seem to thin self to be a fine and sublime person, when the listin realing relian, and meath and heartless IV I "And how this comes as a question which I—I, Robert Grenville must answer. Am I myself a person of this kind Most worthy Judge Eternal—I cannot think except by supposing myself before sometsuch judge if this be so, to what depth I must have sunk! For nothing can justify me in my present condition and situation but the fact that I am what I think I am that I mean my feelings, and shall be true to them not in imagination but in reality. Do I mean them? Now comes the time for testing whether I do. And I welcome the test. I am impatient to be applying it, like a man who hits himself to make sure that he is awake. It's no good my hitting myself, or I might do so at this moment; but I shouldn't be a truer lover because I gave myself a black eyes How can I laugh? I am not laughing really. Let me just state it over again-my whole case as it stands. "Suddenly, during the last three weeks, that strange catastrophe has befallen me, which when happening in the sphere of religion is commonly called conversion. A something which I had always considered as something of secondary value has bewildered me by showing itself as the one treasure in life; and for the sake of securing this so I have told my soul—I have already sacrificed much, and am prepared to sacrifice everything. But what I have sacrificed thus far has

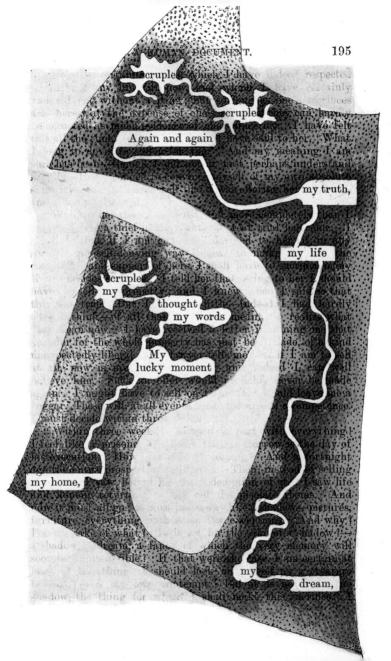

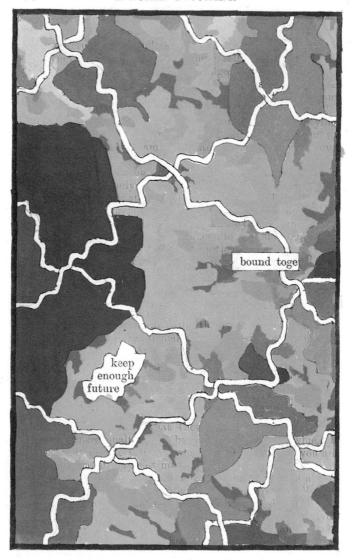

198

CHAPTER XX.

A	· ·
Warder the recording	Mangari Maray or Anthropology, agains again
ame may be the	such a new and expanded
though which there	range to the last the control of
one for residual and	A STORY OF THE STO
international processor processor in the contract of the contr	Appliant The District Control of
and the second second second	The state of the second
was a seron points who we	Layer Course mentioned with the same
The state of the s	Must spile whose minerus on the
eragent Manager Manage	s harmened to me will have
April maneste // Med	The second of the second of the second of the second
	the street of the street was the street
State View entre	in phonesis.
ale Think alse.	hid in a field Mattered
NAME OF THE PERSON OF THE PERS	about three in the afternoon, the
	Charles and the same of the sa
	The state of the s
	at important figure of Aller
	art under
THE LOSS WINCE	the Austrian
wealth its glitter of	made it
Walk and elien. He	art art
Mary M. Lee Lo Herer	The state of the s
	אריינות וואות וותרות וותרות וותרות וותרות או אינייייייייייייייייייייייייייייייייי

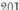

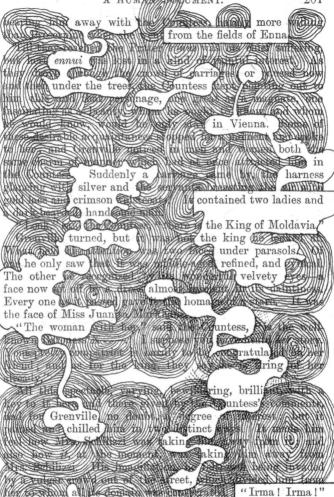

ho one mundane murmur murmur hand waistcoat.

le again rendered to the property of under his breath,

At last his trial Ass. Aver Walker Countess dropped him at MA TOTAL THE MENT SHE norter and him he put into his band a letter Grenville neceived it eagerly, fancying it might be from Mas Benning It was not It was from the Ambassa dress, who had sometrow heard of his arrival. She begged him to come that night to dinner there mould be no party Mendespatched an acceptance resigned rather than pleased and moderation the time came be was little less than miser able. His took and hostess talked to him so much of his prospects land hostess talked to him so much of his prospects land he could not explain that they were now his prospects holes of He was conscious of their wishes for his success But their very wishes irritated him, He telt as jealous of any museus flat would draw him from Mrs. Schilizzi as he could feet and that wanted draw her from him. A strange sensation we dawn on him that his affection for her was these who had bitherto formed the world for him. He was not afraid of the situation. It only made him feel how entirely he depended upon her. Wearied with the fatigues of the day, he returned to his hotel early and was just preparing to close his eyes, and so to abridge the hours which still separated him from her, when the thought suddenly struck him that it might be a help and a pleasure to her if he went to the station and met her on her arrival. To rouse himself now was really a matter of effort his eyelids were so heavy he could hardly keep them agart) But rouse himself he did, and redressed himself; and criving to the station, he awaited her. As the train came drifting in, he half feared that something would have detained her, and his heart gratuitously emhittered itself

figures that emerged he soon detected her and hastened to he glowing with sudden happiness. With a flart of summise and pleasure she gave him her hand and looked at him, but the moment after the pleasure gave place to nervousness, and her voice hardening and acquiring a note of petulance, "You shouldn't have come," she said. "Please go away and leave me."

"Can I do," he said, "nothing for you? May not I get

"No, no," she said almost turning her back on him. "Goodnight; you can east a twelve to morrow." The next moment to saw her lasten toward a man tall, corpulent man The remarks of the first section of the section of

The were at the private and so the electric of the electric of

Ments for age is, and several sets of bottle classes for liquen scolonred and gilt as gaudily as artist she then On thing more he die othed Vienrese actress. Authors more depressing, anythric more assurage it would be by have been possible to navid and as was the home, to a least one of the home, or the man whom he was devoting everything. His hours of the rawing rooms at the Embassy, and compared them with it, seemed to belong to two whelly different universes—essent for the lives of people who had not a thought in omnon. A surprise which to could not analyze at first out of his mind, and made him forget how the time was bareful last it gave place to wonder as to when Mrs. I wind present herself; and wonder by and by gave being and rese ament. of promacted waiting e of doubt, of hope, and o or the rack, is, in h ardest for some terms Grenville mment to be o eat he soon was er dan men he knew what cam was his self-Now he come himself at its in savage came leaping into his committee len in unexplored jungle of his ton woman who ing lor mean while in stood amongst them o kill them nto silence, and vet stren heir way, on the woman iemorable day, he had in led with her before out the bitter things of quite forgotten. And only last night, he a new kind. merely this was he mixed with pain.

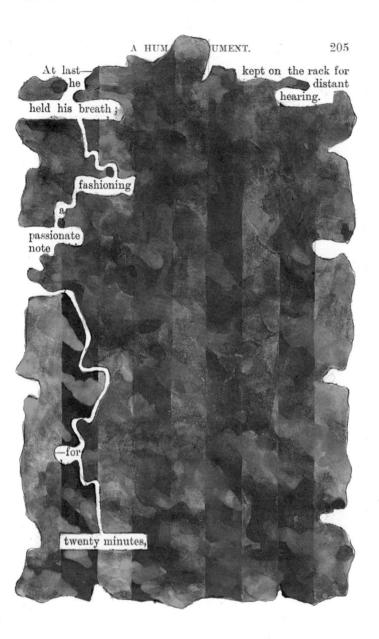

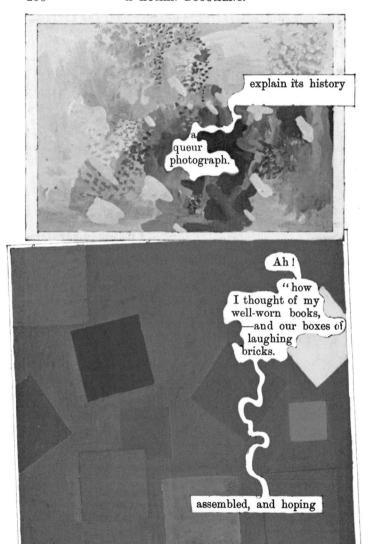

As for the photograph,

and the weak who exists the comes seem of the comes seem it, it if patched and another the comes seem it, it if patched and another the comes seem it. The committee is a committee of the commit

He saw her as he turned how heavy his hand would feel od, which at last hieff for ever for the between them laden so he felt—a naked reached Ld the dirty passage an hour or f all this grew deeper and and a said and a said.

are no Time see that the first the second se

with an but the must be site to lord to deal of the state of the state

two staring oblongs. He looked on his adeboard an unnatural blank favourite painting and the from it. He looked at a drawing Management The home was floor to go. In his looking glass ing the wife of a few that ards of invitation. One of the properties that then with the control of the control the the mollow of the Carboquery strenged remain orrell the said of referred to this her bespresses the little Beginn -a small and brilliant concert, half a pull remembered his hostess when he left, coming to foor of the room detaining him there in conversation, and going out with him into the corridor; and he thought of how presently he would be returning to the same house, not fulfil but to destroy the hopes that were then forced Here were two people—his lawyer and his hancello Thom to again from and there to proper to the formal ormidal established would have to be munical with a clean to be for the first and the fir anderes with a property of the search of the the time of the second of the ne region is it. just as the highest arovery inches than the absence, of fear, while centernaturous of his subdiced conduction. fixulties by a strong offort of w districted al duties. First of all began to write the Enowing when he took the pen in his water oing to say or what position for the same ion ever scattered and Times was war a por gather them toge Man Stief wall DIPA COULTAIN ME the the second that the second have a second to the second the second the second to th to to every phrase of regret flatter the matter

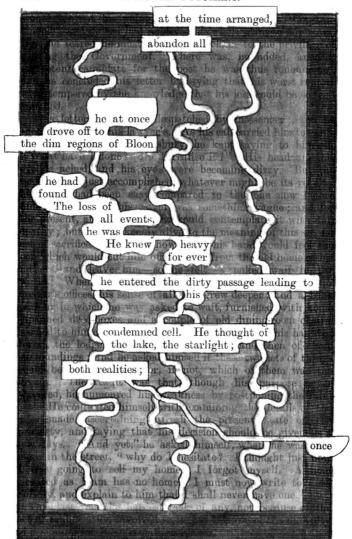

A HUMAN DOCUMENT.

lying on his table; the chance

Vice

Eve

time stopped everything. how he should proceed.

painted on a background
by mere
thinking
accomplished,

accomplished,
three things, his ambition,
a home. A

him

limes are tremulous like a star but, ke a star section his class far away. When, he exc n whon shall (see Val again? His whole soul seemed to be saying to him world "A A sould furte alone in the world" A A sould a seemed to him in a homelier and when be thought of the evening that now Chould be dine at a club or at a vision where perplexity the door throbbed with with a note. a large envelope a card for a party at the house of attering words. The moment he entered the party rocades leamed, and There was more than one but one

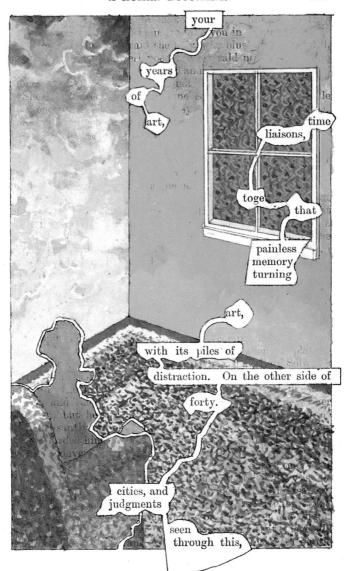

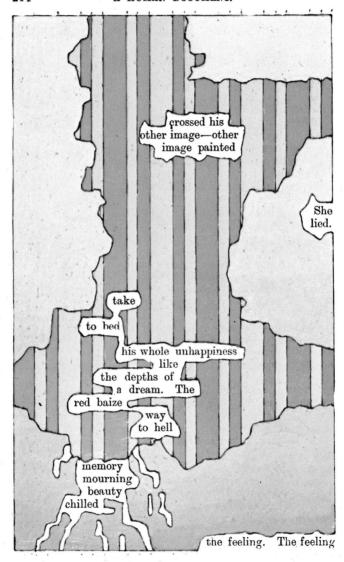

not at him ammand, but the manner Took proper to it, form the of habit this and produced the let's no any one was a have hought of three occasions that he had happy victim to the that were then detaining him. Several observers indeed did hink so; but observer ould have known that at the very men and the name of an absent what still scretly on a sign and that the form of a large went to suppose the name of a large went when still scretly on a sign and that the form of a large went to suppose the name of a large went went to suppose the name of a large went went to suppose the name of a large went went to suppose the name of a large went went to suppose the name of a large went went to suppose the name of a large went went to suppose the name of a large went went to suppose the name of a large went went to suppose the name of a large went went to suppose the name of a large went went to suppose the name of a large went which we were the name of a large went when the name of a large went went we have the name of a large went which we were the name of a large went when the name of a large went we have the name of a large went which we have the name of a large went wh this arm as he went to be pollution thus drew this close he day in London. when at last he per to be next morning had not total that it defeated sick by doubt tw he held them in his hands, morning came, keep now was so erversely of the held them in his hands, was so erversely the first was none from ing that there was none from her however the wording was curt and almost careless; it it begged him to call on her to much that the wording was curt and almost careless; it it begged him have told my mother in a word it would have to consider that as a sufficient explanation of you existence.
In one way he was/delighted. He would be with h and there was some a warder twelve in Downing Street; and there was some a warder twelve in Downing Street; and there was some a warder twelve in Downing Street; and there was some a warder to full of excuses were not perhaps very accurate to the full of excuses the day been to find an hour when the songer with a series of the full of excuses the day been to find to some at four Here was a double annoyance.

used sense

blew through his mind

turbe he could hardly breathe.

bulated figures, with feathers,

lying on his chest and smothering him.

to tear in pieces

and open an intolerable anal

secret

h these last

QUANTITATIVE ANALYSIS (INTRODUCTORY LESSONS ON).

the misery of tearning the windows him showed oke Whee disser who some from see most increa De was paper flowers in the fire pare, reny . look some large, ont por beautiting SIOUS large to hi a ladies a harman edged in black, of tombs. The Contract of the Contract o o bus ivory he s-men. re w with burden, the a was a volum for every Day in the Year; and under this newspaper newspaper vey-prece, ven e discover and ex them, some ion; utila avere man British ideas my and deterence h the sould of hexobjects modes of th discussessay noment and le was hen ar unexpeck maisem t. wantement re, executions

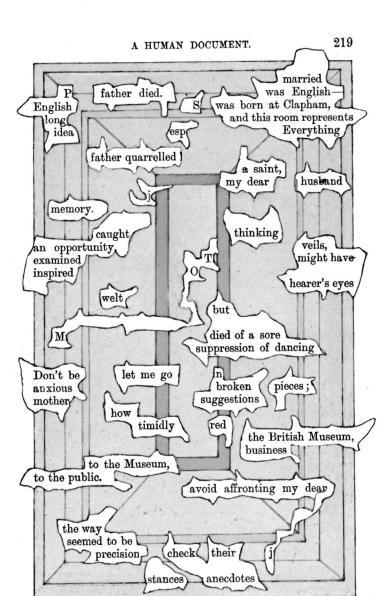

and as a sign of heartles Here he was, half separated from her, seeing her out this beautiless interval, longing to breathe to her some of devotion, and to receive from he the comfort of son her and her deliberately wasting thi short golden op e in idle gossip about Greek vases and a mother blaw, filled him with a bitter and growing sense ithe He made one or two further that he was attempts to force her to speak more seriously; but he made She reverted each time to topics more r treatment, and har tly and a understood not What time is it? late. Perhaps vo He had not e stared at her in voice which sh " When shall I see vou again come again of you don't wish me "Bobby !" How silly you You had, indeed, better go now, and you wish to s looked at him sion. She came with distress in he dear ?" "I feel," he said "that you have hardly let me you, and now you turn to visitor, and you will not on brouble warself to te if ever, I am to see you again. "Don't," she said don't remain any longer so el as if all these rosewoo d chairs had eves to a ons place night take me afterwards to luncheon. I will let you know to night. Pease don't be angry with me, but go." Half soothed by her parting words and manner, and yet still embittered by the unnatural constraint of the interview he vertical into the maze of suburban roads, and heavy with so of desolation, began to walk towards London. (Br

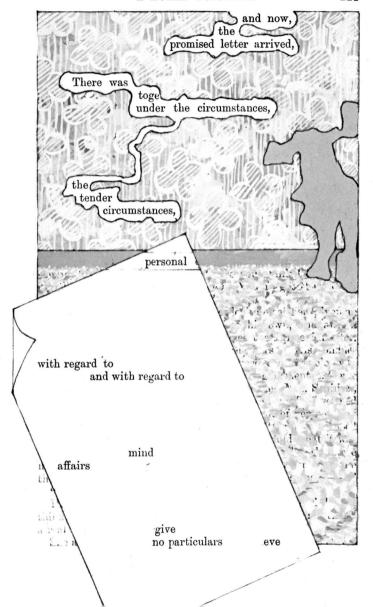

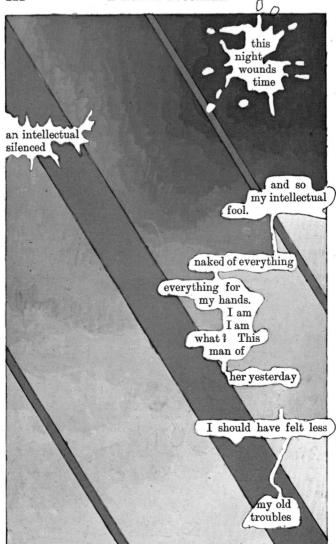

er spens to be absolutely nothing to her, exce I annow how by letting how see my suffering men be like that I don't timea I can plead for you, and the out a case for still produced in then the hears is the dis still and thing the man by I have t thing the many place that I refute all All Marine Luping expectations of it. I will believe from head winning, that you are still the Prine of that by take and forest, who was not ashamed to tell me all he process or to show my hor eves with teres in them. Yes believe that even if I cannot feel it. Will make spart (Now All Loubts of this kind, how weetched position soms by the way assume asserthing to the companion that this ment twenty-four and these followed by hours of hours to stretched and en a rack And yet—and yet the to your a you have to not you have to make you everything." After he had writed the to you stored you at one sentened repeating stretched stretched torrored on a case for wrater until an stiff wore written afterwards. days went by and nexters and not ments the time he uset her she would, once or twice at least, he with her old expression, and speak to him with her old west but always in the bast round there seemed to be holyshed inger, which would storing out at 1/1/20

new not for what reason; and, worse still than this, when her anger was hushed or absent, and when her eyes were kind, the had an air of preoccupation which he had never noticed in her before; and when her words replied to him, her thoughts seemed to be wandering. At each successive meeting, from its beginning to its close, he was hoping every moment that she would break through this strange disguise, and show him her rue self again—the self he had once known. But he hoped in vain; and even when she sail Good-bye, something right remained in the lines of her softening lips.

emained in the lines of her softening lips.

Painful and perplexing as these interviews were in them. selves, their pain was doubled in the memories which they left behind them, and which permeated the hours he was away from her like the virus from some snake's bite. And these hours now formed the great bulk of his life. Some of them were occupied by his own business matters; some by work in Downing Street; and for each night he had some dinner or and engagements left him long miled, even had he wished to do so, he would generally have been unable; for she left him in such meertainty as to where and when she would see him, that he arely could make an engagement four hours in advance. He was always returning to his rooms to see if there were any etter from her; and then, when there was one, which settled their next interview, he vainly tried during the interval to alm himself by walking, wandering away 1000 the spirith or nto obscure streets; whilst life was for him like a tay of from n hell, and his thoughts were like birds with the life of twights with the life of the burn them.

Jused," he wrote in his divry on one of those unhappy, "I used to think, before all this happened, that I had blenty of self-control; but A don't know now what's come to the Certain words from her, even little looks and gestures and had make me, heside myself. My wretchedness is like the seife wretchedness of a child. All these how got up to mock the Through conversation, through music of the desolation to which she had then I can't help it I get the desolation to which she had then I can't help it I get the desolation to which she had then I can't help it I get the desolation to which she had the words and I wonder if any one ever had

violent little acts

Once when I caught myself

cursing Irma,

a penny de la

spent 1 at her banker's. The day after Irma Mary Charles

I paid some money

philosophy at a shop,

boys and a policeman all began to stare and the control of th

Don't you know I've no time to spare ?"

CHAPTER XXIII.

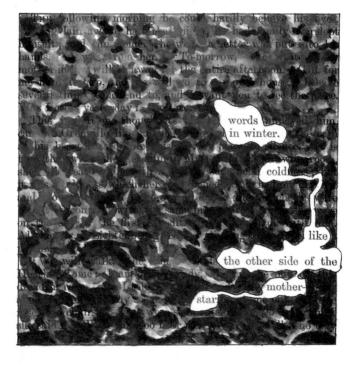

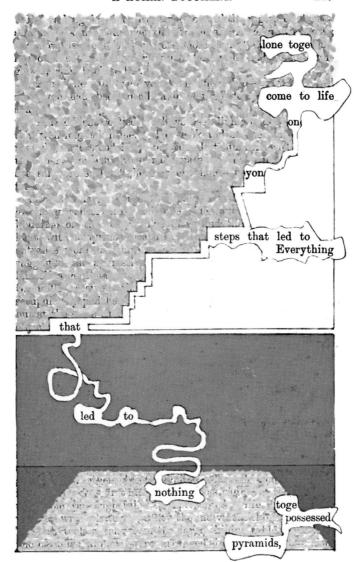

the capet rich to the but most rous in design and colour, the crude vulgar and a stating nound for every street.

Grantile and more than the group to have a fine collection you have

"Pad," she rophe cays that there is it is a more that veddin't leten my parties mere than the price he paid to: it. Come— will any you his roun."

This was full of florid entred recipies furnition, much recombing the control of a firm of a fir

You wond, said his. Schlied and the portal of any schools have Pett is afraid of the mother, viril eyes are at quick as are we. She tolerates those horses only of accepted protest; and the takes him to course with he every Standay trice. Oddly enough, in Fighend he thinks she is quite right; and for this reason he prefers living scroud."

"What a borns," rlough Granville, "for sul a wemin as this to be a lead on to be some with green

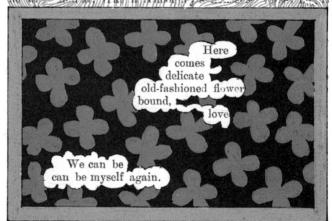

her pieces of china him, starting The saw the volumes the rim and explaining a child, blots and pictures made on margins and SHO her miniature and all over her childhood fold them Paul photograph features w who bed been hi lifted from his heart, The first inpulse had been to tell co stopped himself and he returned recognition him thyle without asking his meaning is and she said the is time dur me to be going You must leave me here. You must on no account walk hac A Tell me," he rewined D when shall Comorrow L' Ab ... she exclaimed T wanted 46 you about Man Tomarow Lam quite free Mening into the country the country; but the

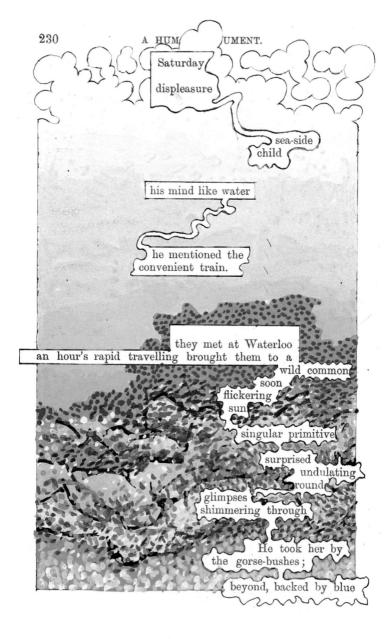

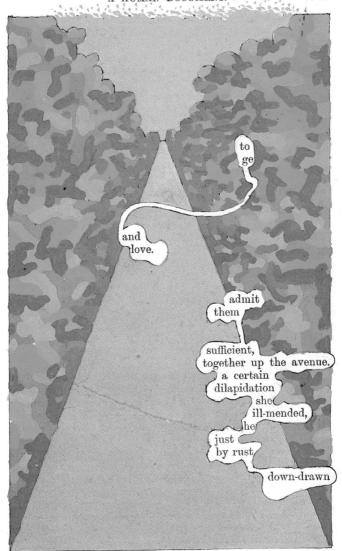

magnificent long gallery chest boots matting with pungent with smell of revelation; appreciation my moth dead. My moth I remember the (that quivered the corners closed mouth coming. His face blind the wall his lip, his eyes pointed

A HUMAN DOCUMENT.

my moth London. Poetry and prose Signs and on a London, silence laughed Liverpool Street, gliding London behind the anxieties

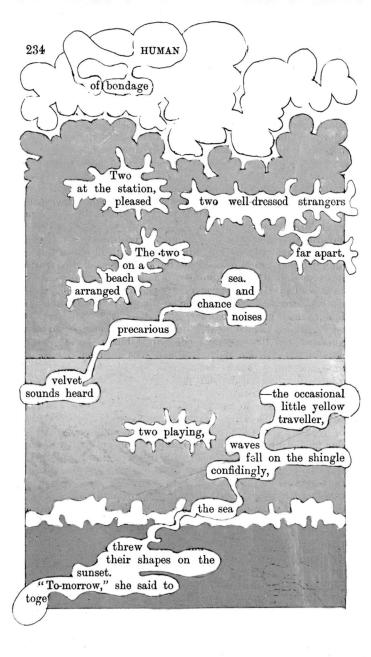

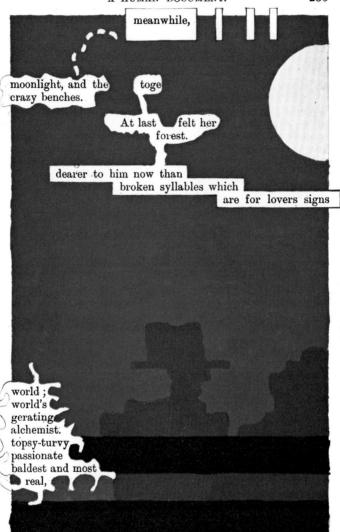

house success burning to your houses, and where sometimes as your source, soil where sometimes are not consumed silence, sometimes are increased at a consumer of soiler and sometimes are devotion. The wind the property of the consumer of

Without have exceement when Town words not only still but processes and my heart is so full of what they mean some of losing in that they would be that they will be to the losing to the they will be to they will be to the the they will be to the they will be to the the they will be to

sad a restriction of horizon of sea. A Thick men heaten and h the hours who devoted to her thate HOME TO STATE SHEET SHEET STATES sing occurred she spent with known Legal Allings English Legalinis her sadness returned again boor very meet evroy versit manifest be Four we not been angry with me because I we given hours to my nices, and yet I am sure it tried yen. a seems beadoot some rever productive, with view at wend terresolvot sittle evolt die zakreob bedonat ar ute 1 yet oh, Bobby, Bobby, there is something I want to say to you. I wanted to say it last night, only I hardly knew how: and all to day I've not wanted to say it at all."

"What is it?" he asked. She hesitated and blushed. She began to speak, and then stopped herself. What was in her mind Grenville could not conjecture; but one thing came better to his view than ever it had done before—the fact that for him she was guilelessly and defencelessly truthful. There was something almost painful in the degree to which this touched him in the new and sudden call which it made on his care and tenderness. "What is it?" he asked again, "Tell me. I shall understand, whatever it is."

"Yes," she saids "I indeed believe you will. You understand me too well; and it you are too good to me. I think hear toll you now. You see, Bubby, my loving you you see

the state of the control of the state of the state

"I veilt 'ne solt 'per free free free the le V be 'lefo m sel i 1 hito me al 'em, or on a lefte."

I ondem to, or whe hink it is it only is not lefte.

It in y u as part of his set only is not lefte.

It is the ode of a dry blance left erless. I'm y to hip clift, is the ode into each yet the His yet of gree if the general result in J. Jan. Yet and the general result in J. Jan. Yet and the general result in the general result in the general result in a restrict in J. Jan. Yet and the general result in the general result in

believe heart lied ax of yar and derive it that the same at the ear and lie to cell you converted that the same account, it, ere) be the spill a same in the methin back if ear again. I'm art of esentil that methin back if ear is then form of the earlies shall be s

Let 4" and envil was have just be ying.

To vot up the now go also

the synthese recording to the now go also

win allow no, the recording to the norm of the norm

"Yes?" she gasped "Is it anything very dreadful?"

"You remember," he answered, "that at your house the other day you showed me a certain photograph. Well—I recognized it. I have already men the original. I travelled with him from Paris to Vienna before my visit to the Princess. I talked to him. Listen, I will explain to you all about it."

_ "Are you sure it was he?" she interposed "Was he alone?

I believe he very rarely is."

"He was alone in the train; but somebody was with him on the platform. He told me who she was. He was very frank and communicative. You I dare say, will know what I mean by that. I don't want to dwell on it, but I want to tell you that since I made this discovery, the chief uncastness that lurked in my mind is gone. I only knew it was there by the relief it has given me by going. I am appropriating nothing that he either understands or values. I always felt that this was so; but only now has it been proved to me. Can't you see with me what a difference this must make?"

She looked him long in the face; and at last, turning away, "I am glad," she said, "of this. It makes me also happies You now see what my position is, and how completely, except for you, I am alone. Please don't fret about me. My heart has been lightened as yours has been. I am happy. I am

alone no longer."

Now next day was the state of her mind changed. The thought that this peaceful interval would so soon come to an end did, indeed, sadden both of them; but it was a sadness brooding over peace, like clouds over a quiet sea. The mid day post, however, brought her a letter from London, bearing many stamps on it, and darkened with re-directions. "It is something from Paul I" she exclaimed. Her cheeks flushed as she read it. "His work at Smyrna is nearly done," she said presently. "and—what is this! There are some new waterworks at Bucharest, for which the firm has a contract. He will be going there in three weeks. He supposes that I and the children are at Vienna or with the Princess; and as soon as he is able to de so, he will some to us."

She dropped the letter on her lap, and looked at Gronville silently. "Of course," she said at last, "it must have happened sooner or later; but sometimes, Bobby, sometimes

one forgets things."

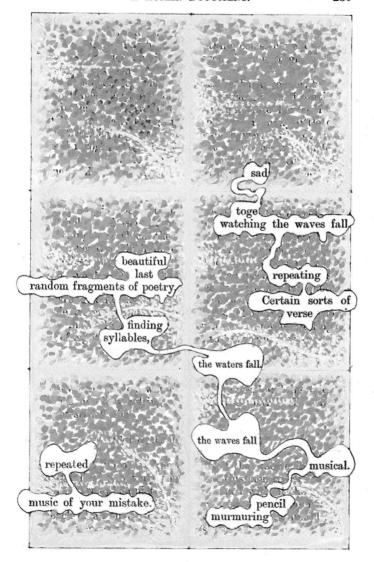

no future. furniture

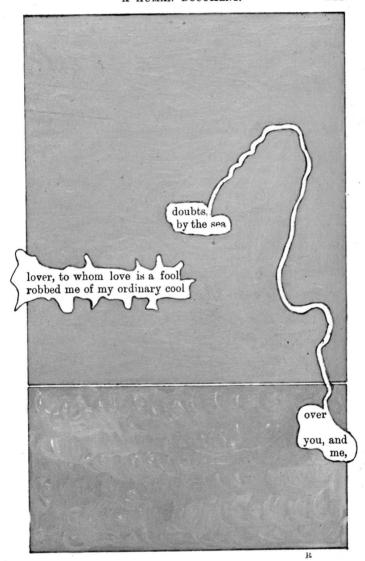

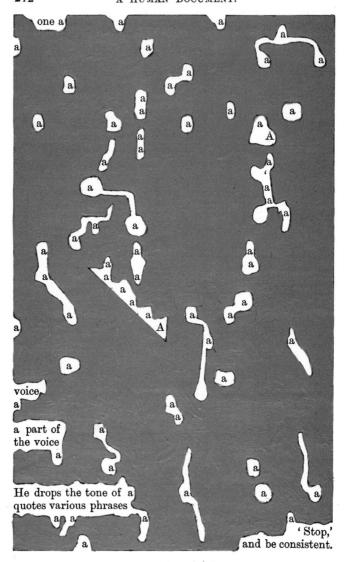

burnished piston-rising and falling, fully (

the perfect skill of man.

wonderful, wonderful

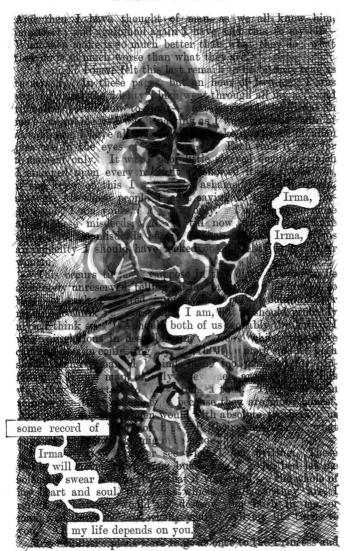

what to call it. I am beginning to see that the same thing holds good. Some of the most pituible are those that would be least pitied. I think this week I have been almost mall sometimes, and even now my temper gets into my pen, and I talk of the devil before I know what I am doing. I am fool fool part yet I am not a coward to all the world A What is the cause of my wretchedness? Many that a woman in ten days has written only three trues to me and one of these times only three carcless lines. What a trilling planuty that sounds to one who reads of red but, to me who led! at what has it meant to nee? Here was worked to be the less sake I antreportering very three I am remaining in London for to other reason than to carry the death of my ambition, and the act that will make no house thought I have mentally brought to her, as some cannotic votacies lays flowers upon an alternation that has given me any real comfort has been to write to her. All my hours of exertion have been thour which was dedicated to this writing. And each day all my hopes naturally were to hear from her. I have been accustomed to reason with myself from my own experience; and browsing how to write to her is for me a daily necessity and knowing how to write to her is for me a daily necessity—how every day I am straitened till this is accomplished, I could not but conclude that unless her affection were decreasing, to write to me would be an equal necessity for

her.

"Two of her letters have been almost worse than none—evidences of carelessness far more than of care. I was patient at first, though disappointed patent at last the gathering pain burst out in my mind like a last of bitter water. Much as I long to be honest, I cannot, for the sake commit to paper all the things I have aid about her; and I cannot, for another reason—because ho words could express it—commit to paper the misers in which I said them. But the kind of judgment which aid these moods, I have passed upon her, I can describe in the first terms. Just as her connection with myself has lear innobled and sanctified in my eyes by my latieving it. Thave done, to be the result of a serious caprice, where strong enough to have the semblance of

insettshness he hole condition and process are ntirely
changed the contempt, to be equalled only and own
contempt, to be equalled only in a own
will be perhaps as well if I
record wo specimens of my accusations at a trans-
and so will not satisfy the new even the new ter out
aversald A. A. does she toes at serrice
and seewill not said to be even fire problem out aversaid to be feeling so the stays the period of the country feeling so the stays the period in I have marined myself
things you caused life, you value
your children, to your clothes then
after your comfort you fancied you
Tancieu you
k like
the completing for her sake the ender of la puspects. Had I been forced be solitary,
d puspects. Had been forced be solitary.
I should have gone mad. I have tantly
ociety by way of a counteringing id the
nave was in the world has seemed
te who compared with her cruelty
whom should in the Lady Evelyn Sit Was she
whom should i in . But Lady Evelyn Sir Was sho
different or was I different, from what to was at
Vicenza: It seemed to me that there are welcome
The state of the s
interrupt us; and I remained at her
the evening. And I thought, 'I am give that
hard, thankless woman!' And yet, all that
a single moment did I let voice or look con
or feeling which was more than what a free wight have
conveyed, or by which that hard, thankles and the
have been wronged
Vere my to the this the mould be just
described. The this the mountain votes just
misera de la la casa de la
story. I we said that I myself have been provided
int in
32 the spirit, which in lacerating h
has for me as for my real self-I wa, ashamed that

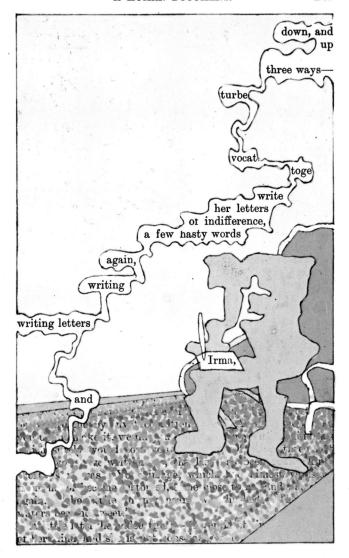

The stranger knew all of them

royal personages diplomats, stars of society.
our own ambassador at Vienna.

Lady Ashford

the Pasha

whose balls looked like four milk-white horses.

all was to go to a neighbour even my luggage, and that small bag containing my back,

dismay to grow bewildered, the clipped blinking I entered a great bowl at first. light broke from her. for years; her voice looked strange. Have you felt that this was likely to reach a noiseless moment, mo put off this moment

A. Take Hall State State

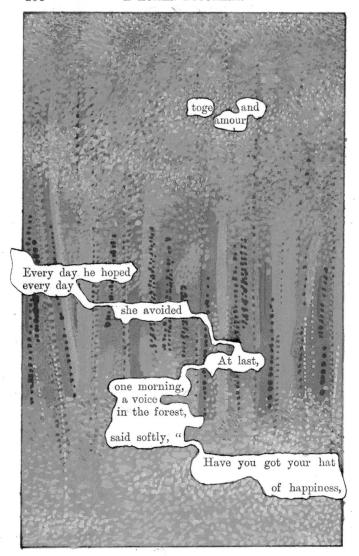

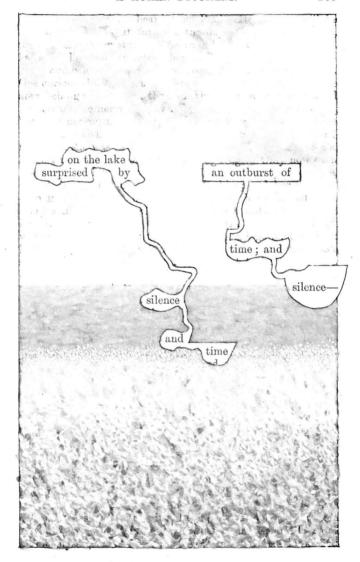

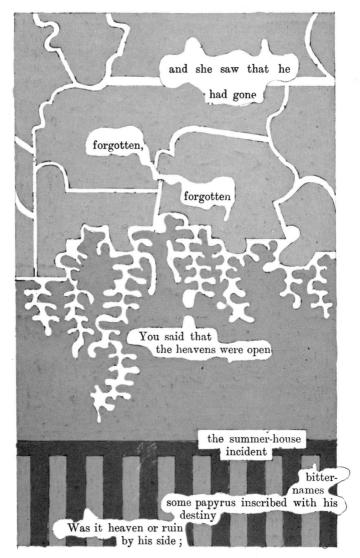

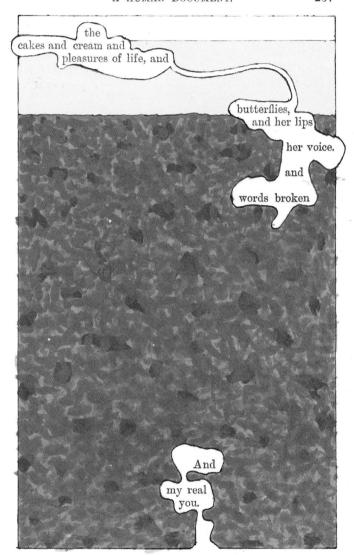

—I foresee it all. in the garden, little to say. a crumpled last night

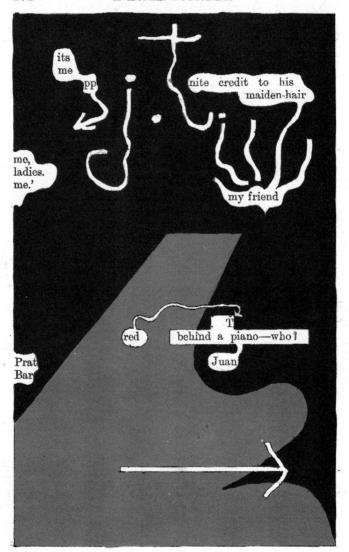

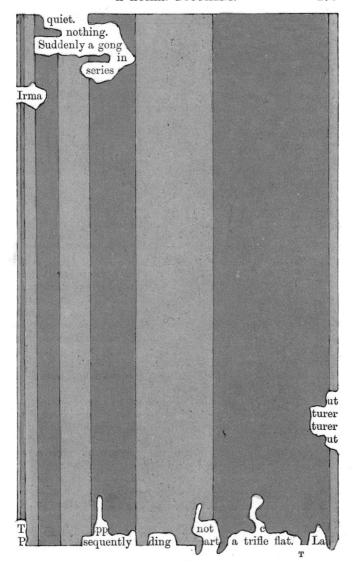

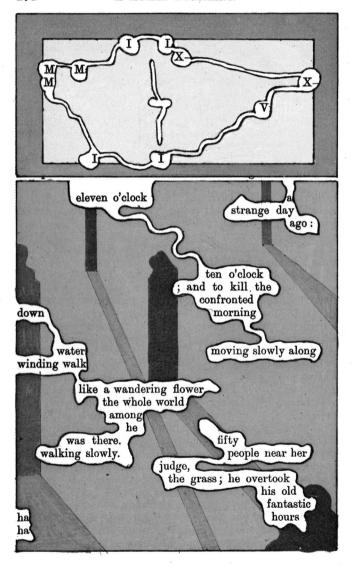

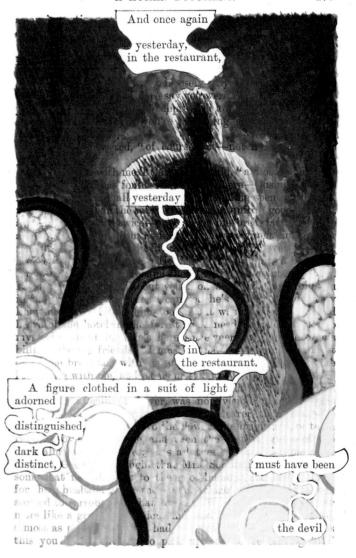

the moment changed, a moment ago

sidling coming to me. prosperity.

clairvoyance,

deep quiet of the service of the past.	moved alor	usideratio		ris com	.1.4.1, 4	- 1.0 - - 1 1 -	
deep quiet by the state of the past.	knew whee	Jh				1: 10	
suddenly with the state of the past.	deep quiet	of the e	austry, an	d wakin	1-11-1-	1	
nfluence of the past.		CLT CET	-,11-1			the riv	
nfluence of the past.	mı,		-1- 1-10	Li	11	· · · ·	
suddenly with the state of the past.		:		1-1-1	1		
nfluence of the past.	towers, at	1.1		on the	e green	floor	N a
nfluence of the past.			. 10 -	· · · · · · · · · · · · · · · · · · ·	• • •	C1 :_1_	
nfluence of the past.	zeoù mue				ı 'ı'	The same	
nfluence of the past.	aired the	Lulres see			1 1	4	1:1
nfluence of the past.	Lift of Le	w substitution	suddenl	y late th		ETOHO:	enound
nfluence of the past.				1 1		l	
nfluence of the past.	1:1 / 1:-	41 12	-f. 11	,			1,
					L	to bin	<u>-</u>
	Rudy of M				0, 1	y to a	
this is a second to the second		1 4 4:11		1' 1'	3371		,

Meganow action is reserved. When we enser in such a situation as mine, what problems it may in time reveal to us. It is like a plant whose thorns sleep in the sprouting stalk. It must root itself and grow in our lives till we really can know its nature. This man," he continued, "I can't be uncivil to tam. Why should I be? On the contrary, I will, unknown to him, do him any good turn in my power. Only it must be unknown to him. I will never have him thanking me; and sever from him will I take the smallest favour. And Irmawhat of her? Does the situation to her seem as hard as at these to me? She appeared this morning to be such a complete mistress of it! I ought to think of her far more than of my self. My moral anxiety was just now too selfish. And yet in a way, things are simplen for her than for me. However trial and friendly she may be to ber husband, she is mercay paying him what he may have be been husband, she is mercay paying him what he may have be to ber husband, she is mercay paying him what he may have be to be husband, she is mercay paying him what he may have be to be husband, she is mercay paying him what he may he to be her husband, she is mercay paying him what he may he to be her husband, she is mercay paying him what he may he to be her husband, she is mercay paying him what he may have been husband. He will not have been such as a contract of the may have been husband, she is mercay paying him what he may have been husband.

sometimes far more rapid sometimes far slower.

"What is it that has put him out so suddenly?"

"I think I can tell," she said. "This dress I have on to-day—it's a great deal too smart for the place—but it struck him how pretty I look in it; and he heard, in the hall or somewhere, a Russian Grand Duke admiring me. I knew exactly what passed in his mind; I have noticed in him the same thing so often. I became at once, for the time, a valuable possession in his eyes, and he was determined to show me off as his own exclusive property. He doesn't want me himself; and as long as nobody else does, he never would care if I lived and died alone; but the moment he is reminded that other people may admire me, he likes to take me about in order that they all may stare at me, but is perfectly furious if I give even a smile to them. This afternoon," she went on, "he waited till the gardens were full, and then he walked me about wherever the crowd was greatest, as if he were a peacock, and as if I were his tail. I was so nervous, for whenever I turned my head, I felt his eyes were on me; and he said 'Who are you tooking at?' However, as you see, he is perfectly quiet now he was said with me on your account for no reason person to morning, the word if if you will not be out of reach to-morning morning, the passeng lately. If this is so that have a note by ten of clock."

passing latery. The table of clock."

She was as good as her word. The note arrived punctually, and the news and the proposal conveyed in it were far beyond Grenville's hopes. Mr. Schilizzi and his boon companions would be absent the whole day, at a town some thirty miles distant, attending a sale of horses. They had, in fact, started already; and she proposed that Grenville should take her and the children to visit once again the hotel and the hunting lodge in the forest. They went, They picuic'd in the lodge.

see the breast on every star

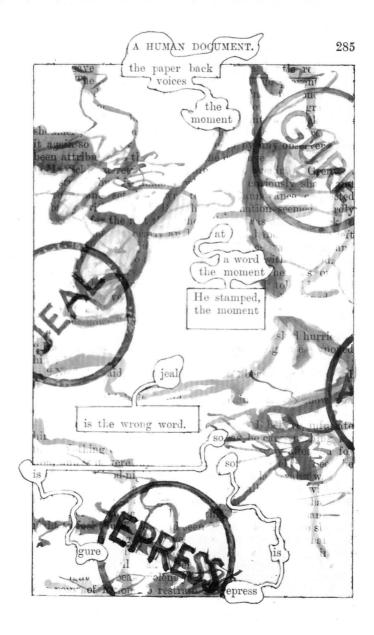

dissipation, and the animal curves taken by the plausible

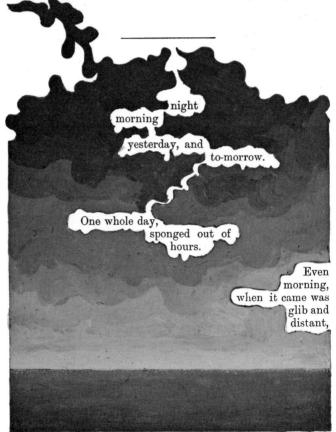

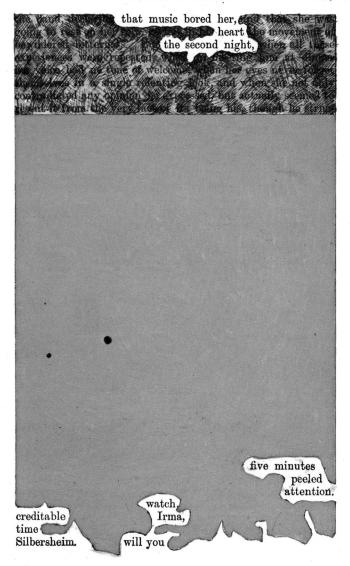

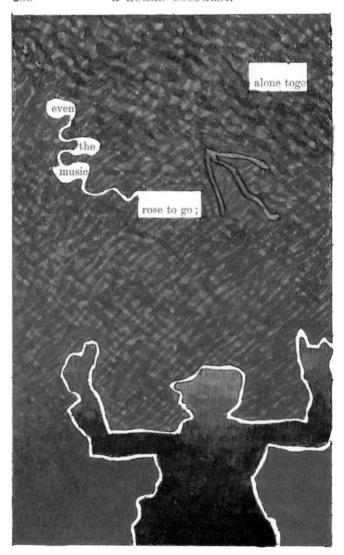

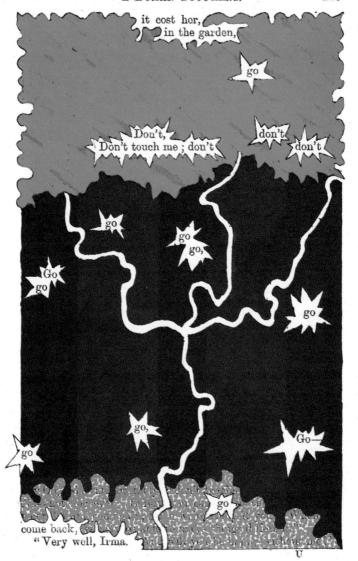

"I shall have you again by and by," she said more calmly. look my plane is "Where are you going ?" she asked. He raised his hat, turned on his heel, and went below the surface,

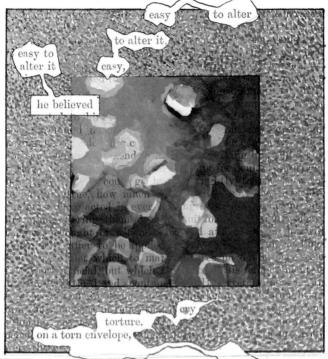

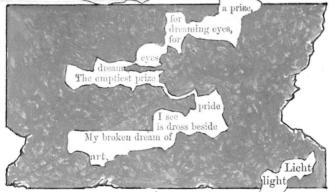

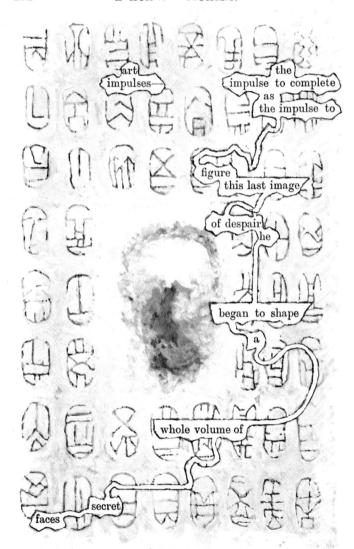

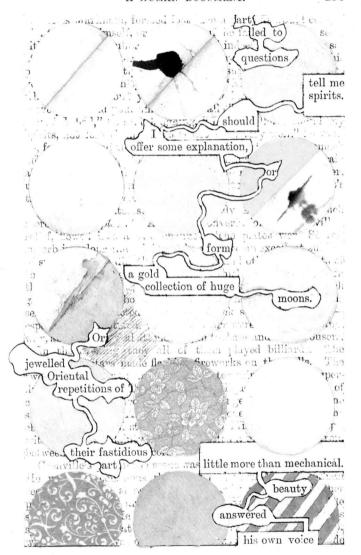

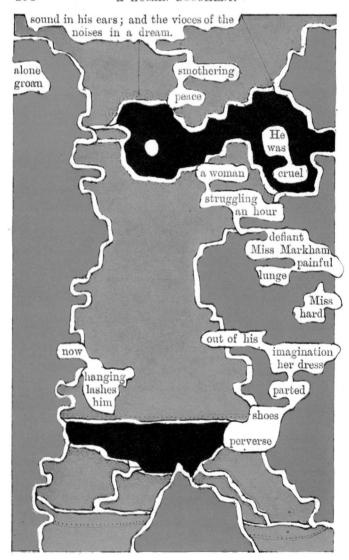

a walking- pocket-handkerchief entered,	good-morning handkerchief Just smell the world
	ten guineas a bottle. Our mischievous bottle in bed-
Gren	
have so many buttons I may Help me. There's no one com	y as well begin undoing them.
Mildlinnisteratus masteritusions	anni dhalanni an an anni anni anni anni anni an

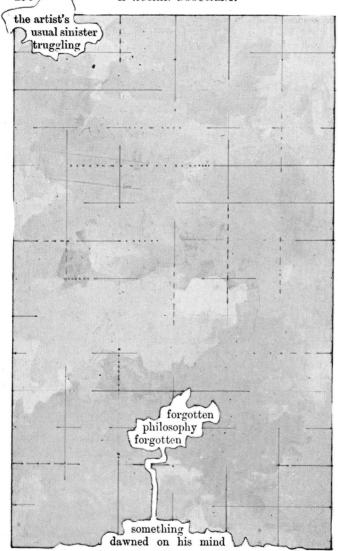

Miss Mills the throne which the aford ent fained it, to gave a cresh inpulse to the b drove back, and without hesitation hest's proposal that they should enjoy before agarette in the snoking room.

g this Grenville was doing a real work of ha's experience and opinions were so wide ensive that there were only a few of them his happy audacity he was able except in cor to ladies v like a sunny and babbling stream row contempt for jokes or anecdotes that t. The ger calization at this—that no attrehment was ever No, no, no," he laughed. "You diff you only saw things as they are, y delighted with what I say. What can be better? progress an ascent towards the divine, not Your Platonic affection—you can always hads. Consider you now our esteemed fri tonic.

UMENT.

chance words

is in the state of the state of

the second of the second of the second

His aim was not to think. His aim

The same of the sa

in pullbook in the property of the month own distriction of the property of th

committed to music

Let me live my life

libretto. "Let me live my

no matter how the mountains fall

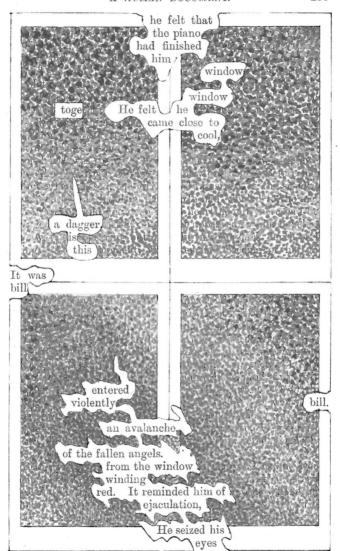

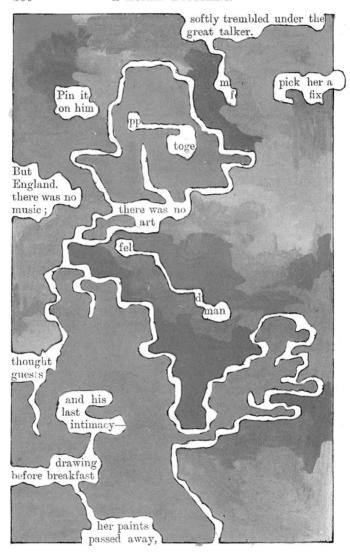

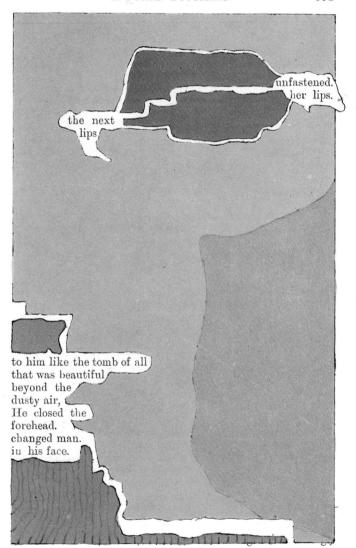

materials.

CHAPTER XXX.

The emotions of men

hell is torments;

tongs, supplied

separated once for all

novision where the little was the conference of God, but a comme whom whom whom who are extra niedośrnie i spiłu i Dofus and and mitehternia i poetafynia w poetafynia i poetafyn TARITTANG POLITICA TO A TENERAL TO A TENERAL TO A TENERAL TARE committees against her each as of treachery. And my will has consetted a But are read the man resulting a state has a said HARLEST STREET AND THE PROPERTY OF THE PROPERT d know what guilt metho as remember a centain morning where the need a zone a second second zing a zone zone riefekilyzerk ever egerscheeft pleische before in elektrek beier new - Wastenen og moon that orensen as feit vere avsense of guilt was treed. Aborror oldstrust of the thittill district of the thittill district of the thittill district of the first time in any life is as a continue to continue to the first time in any life is as a continue to continue to continue to the first time in any life is as a continue to conti Control of the second second second second second Theologian and that they think sacred shot as new inward diglet was this appires programas a sur a programa de la composição de la magnethe darknessis to be see see see see

d had to med x Yeu have tried more But what of their Acceptant and the state of the bere ab the structure as lie ing al following a want spet a se Stistens pous de persus de la recensor de la constant de la consta Ming to take to wondwar wan both eaven without bu miles A COMPONE CONTROL TO COMPONE TO C

अविकारिक प्रकार का महत्व है। एक अपने प्रकार के bk; for mention the page, and abraptly start up the write a letter was find no found book and the letter of thus-

acrifices in order t

ENGINES AND BOIL-

BUDDHISM enlarged FSOTERIC

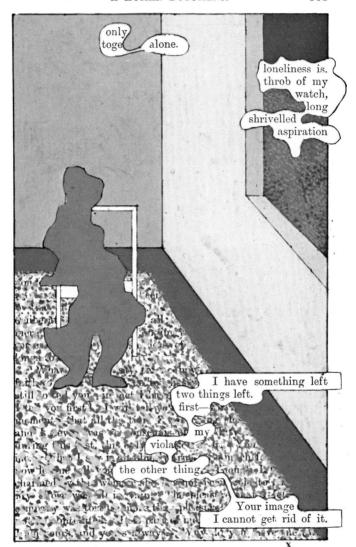

from you I If you do not seem me for this degrading test to which I have put myself, you will see how it ab least prove the strength of my love for you. And perhaps the very strength of my love will make you despise mayer farther. It is does thave but one thing to ask of you. Grant me one final knowns. Let me see our succeasing and when you are extraor post toy to me, it some some confinance in any sill make greatest to us, consuming our past. Does at our past mean nothing. Was a secretic beam of two wicket and fatchiess children, who get each other into trouble and then lease each others? This is not so I know, so far as segards me I connot, believe that it was shown as no as remade you, when I remember the words your lips have your eyes with all your soul in them as they exerted them selves to mine, and the love that shine and revoluted result in all the transfigurations of your face.

"Do you know these verses ! They are not mine, except

that they speak my meaning-

" 'Ah, dear, but come then back to me! Whatever should the days have wrongs. I find not yet our lovely thought That eries panet my visit for month

This letter he scaled up in an envelope, on which he put no address, merely the word "Private"; but which having written the following few lines to accompany it, he enclosed in another, directed in all due form,

"Dear Mrs. Schilizzi, forgive me for troubling you; but you will find, I think, that the enclosed belongs to you. evidently strictly private; so I enclose it in a scaled envelope in order that, if by accident it fell into other hands, then should be no chance of its being real think of the bands. Fru examine it, and let me know of its receip by the beater.
"Sincerely yours R. Chrystian."

Summoning his servant, he asked him to procure a beast ride to Lichtenbourg, and deliver the parties are summly. "It contains," he said, "parties papers, and make be put into the lady's own hands. You must learn from her maid when she is disengaged, as in-wants an immediate answer; and unless you can find her alone, and able to att 50 to the

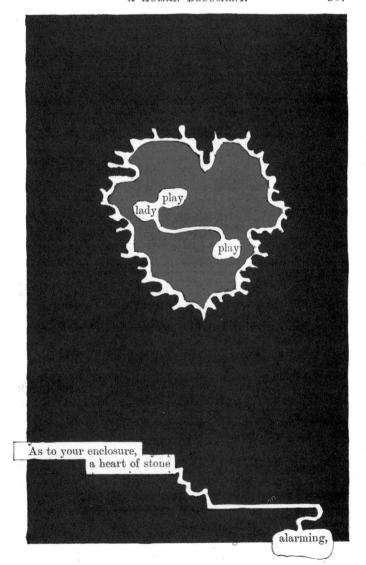

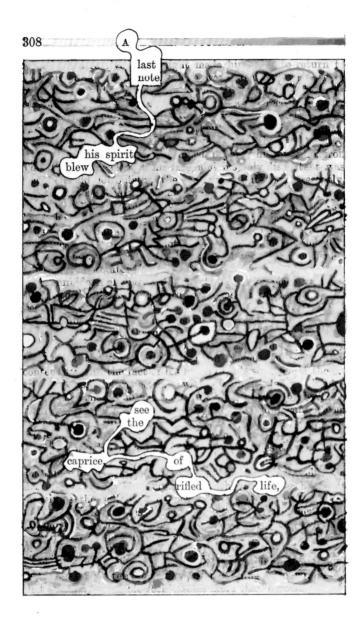

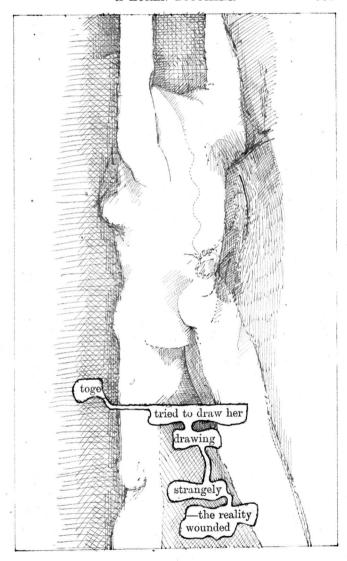

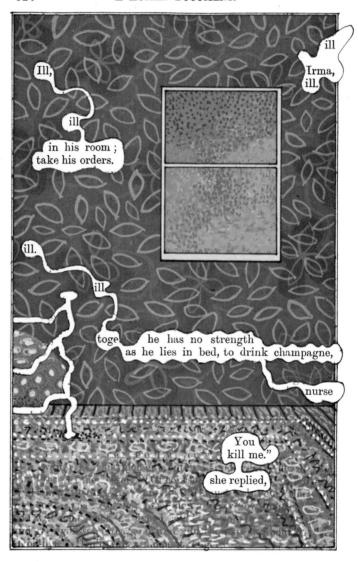

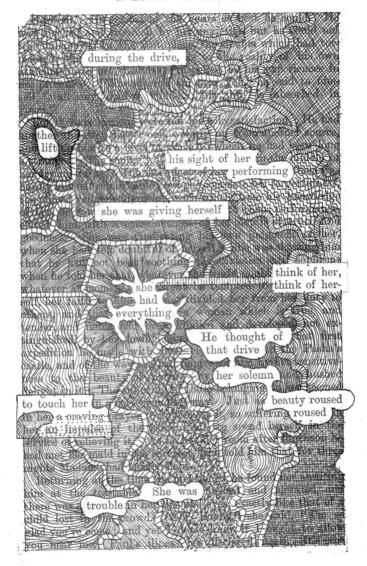

1431324411	A HUM MENT.	111111111111111111111111111111111111111
	what was the ma	tter,
Superior Rays from		Taul Taul
what was the n	natter N	The last tipe to the last tipe tipe to the last tipe tipe tipe tipe tipe tipe tipe tip
	THE RESIDENCE OF THE PARTY OF T	
You hith, based to		
cover	think I must have closed in	ny eyes,
TOX	g else to do; and anyhow so	TI DEG WAYNE
DRA DE LA COMPANIA DE	CO OT SAND WARE ON TO AND TO DESCRIPTION OF THE AND THE OTHER OF THE OTHER OF THE	VE SAME BASE AND ASSESSED OF THE SAME ASSESSED OF THE SAME AND ASSESSED OF THE SAME ASSESSED.
A second to the	to the second of	A STATE OF THE STA
MONING TO SERVICE OF THE PARTY		William St.

She linked into big eyes searchingly. He tried to shape an answer but his lips only trembled. She understood him, Her eyes told him so. She leaved towards him and continued. All this she said is only the preface to my troubles, The children shours they are supposed to be recovered, are still according to the doctor, in a very delicate state; and the great thing for them soon not to-morrow, perhaps, but next days will hard all and of him. They will want most careful

the great table for them soon—hot to morrow, perhaps, but next data—will he change off and. They will want most careful watching for weeks and weeks. The doctor has lent me a book. For the last lies minutes to been reading it; so far as I can see, it may be to months before we can be sure that they are strong exam. Let he what am I to do Where an I to soon them. And must I go with them too it would all me to leave them, but then Boby—can you tell what I am thinking of I I I don't leave my children. I shall have to desert Paul. Give me your advice. Help me Think for me. I am bewildered.

"I should like," said Gravelle, "to share all your troubles, except your bewilderment. It is lucky I don't share that. I think your dourse is clear. Your children require you far more than your husband does. At all costs you ought to remain with them."

The watched to the window turning her tage away from him. He watched hen He heard a slight sob, and a slight movement showed that she was galping down some emotion. Returning to him with swimming eyes. "Ah," she said, "but I feek this." She came close to him. Bhe laid her face on his shoulded. "I feel this, she went on with difficulty. "I have never wronged my children him I have wronged Paul; so I want to rappy him over and over again." She looked up at him with a shedden taomentary smile. "I shall make myself in that way more worthy of you. Don't be shocked at what I say note with an eard so far as my thoughts so, I can though I have wronged him. But from habit, from the way one's been brought up, from the way even conventional opinion has somehow you into one's blood I feel that I have wronged him though! dare say the feeling is irrational, and I want to cannerize him feeling by suffering for him—by wearing my solf out to him. I'm hay be I too at times have a feeling resembling your. I'm want have been shy of telling you of it; but I want to again have a secret

times have a feeling resembling rooms. Till now I have been shy of telling you of it; but I can never again have a secret

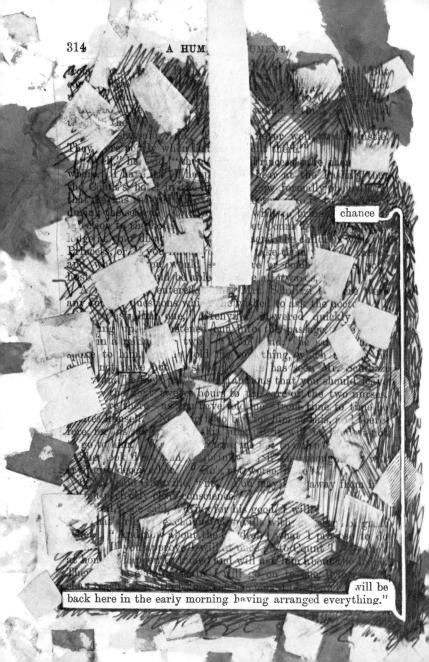

"Will you really," she said, "uo all this for the l".

Her wondering incredulity, which melted as she spoke into gratitude, profoundly touched him. "Do me one little kindness," he said. "Lend me the doctor's book I should like to look at it during my journey."

She gave it him and he was goned He found the Count at home, who received him with the preatest courtesy, and at once placed the ledge at the disposal of himself or of his friends. He then hurried on to the train, which was to take him to the Princess. On the way he studied the book. He fancied that with more or less accuracy to could make out the general course which this disease, varying so in various cases, was taking with Paul Schilizzi. Whatever the mount had done and suffered for her children would not have surprised Grenville, though it might have moved him afresh to some new act of reverence for the beauty of her passionate maternity; but with regard to her husband, towards whom, as he knew well, patience was the highest feeling, and indifference the kindest, which his conduct and character made it possible for her to entertain or cultivate—with regard to her husband the case was quite different. That she should see him properly cared for and supplied with the best attendance, that whatever he wished her to do she should do and do willingly, this was natural enough. But what she had been doing, still more what she wished to do, went far beyond this. So far as his wishes went, his illness made few claims upon her. To him a nurse's care would have been just as welcome as hers; and the only thanks she received were either neglect or anger. And yet, in spite of this, she longed to do for him whatever was hardest-whatever to herself was naturally most repugnant; and what it was to which she was thus devoting herself, Grenville realized now, for the first time, as he read the account of the disease, and the attentions which were required by the patient. She had mentioned to him lightly that the symptoms were not agreeable. He now saw, from something else winch had been told him by the doctor and which fixed his attention on certain special pan graphs that "these not agreeable symptoms" really comprised everything which could try and nause constitutions far stronger that hers. The infected air alone would for her be physical mart rdom; and there was nothing to sustain her, not even the sense that she was wanted -nothing but the passionate wish to he true to an ideal of duty. And for the sake of this she had not only watched and suffered, but had done so, despite all provocation with a tender and unfailing patience. These thoughts possessed him during the whole journey "Quia multum amavit!" he several times exclaimed to himself; and he said "Let me only be worthy of her, let her apply love he, till I die—and I shall not be atraid of deathuilled.

The frammes and form to the cause of the country and of the cause of t

"My maid will see about packing my thing to night and it the children can be moved to many a I shall be ready with them. But the lodge—will that a ready.

"Yes, it will." There is a train which passes your station at three o'clood in the morning. It terms by that. I shall reach Lichten by seven. I will rice over to the lodge I can get there by half-past ten matter the engage that by to-morrow afternoon the whole place is for you."

"You're almost dropping with steps on he was indeed nearly exhausted." I tell you will have been increased in the Princess, "who causes me most anxiety. That Irma with her husband the husband her husband the husband ones not require her with her best with her husband the her husband her husband her husband ones not require her will be sure some state of the princess." I was to sure the husband ones not require her husband with her husband her husband ones not require her husband with her husband ones not require her husband with her husband ones not require her husband.

risk; leaved I myself till this afternoon new very little about it; at I made her promise me Walt, at all events till leturned, he would stick to her children and leave him to the doctor and the aut.

"I" aid the Princes "will write her a note for you to

Ti said the Princess "will write har a note for you to

mish

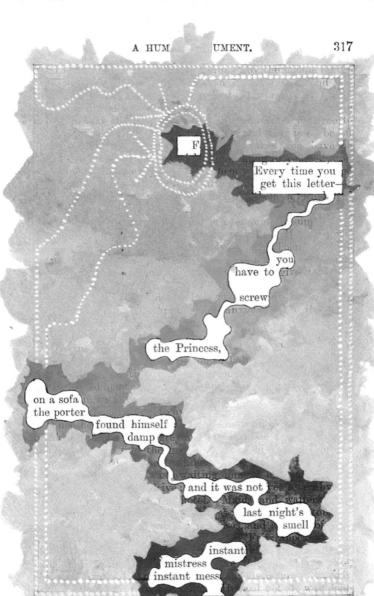

the door of her bedroom opened; and a diaphanous dressing-gown softly came eagerly As she did so through. she said to him. have what you will but suddenly suddenly night, and the room I did whatever there was to do. ; and it seems to me now like running away pain; and yet, when you speak of them, you disarm me. I have not the resolution to leave them; though-don't you think this for a week or so they could do without me."

"You gute forget one thing," he urged. "You might by remaining here make yourself the ble to go to them for many a week, an Irma, perhaps for ever. Here you any right to run that risk? Have you the heart to de Now youldn't run the risk of leaving them alone in the street. Can you bear the thought of leaving them alone in the world your husband, you may safely commit him to the Princess

and I will remain here a so to do whatever I can
"Lyield," she said. I be that you must be used
be away from that so root costs me far more that cor
in it. Oo lear friend, and accomps things as you preme.

A horse was ordered for Grenville, what he ate at his The second of th

ing interview with the firmers has a ranged who was delighted of such an anotion at finding has been a findi he found state

done her boxes that he was servalts, whilst a capation dander specially constructed to The briskness of the Princess's injuner was of great services on the occasion. She told her nince she was "silly and wrong and selfish" for having any refuctance to do what so clearly was pointed out to her, not only by duty, but by ordinary common sense; and with a semblance of anger, who asset like a moral tonic and was sweetened at the same time under current of deep kindness, she almost flove the hitle party put of the house into the carriage, where she carefully packed the children, kissing ther whilst she did so they are drove off she stood waving her whinkled hand at soon, and forcing a cheerful smite, till a turn in the road hid mem; and

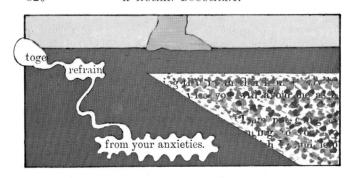

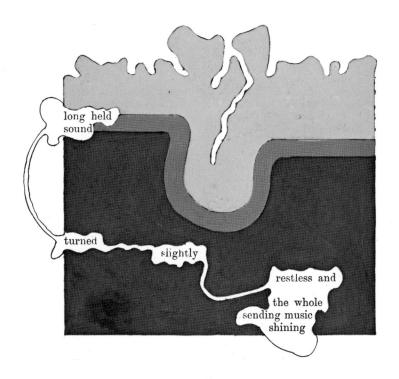

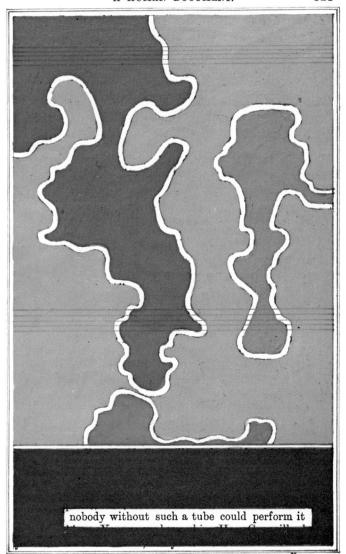

but the fame meaning continues to increase in the threat. Say-le is when a nuise Von have relieved her orgenough? and will frish what have to tell you on ide."

instantly, and resumed with a meanwhile seduces her town a station by the bed. He give her a few instructions, the i

went out with Greeville.

to you quits freely. In fact you can hardly have mis aker my meaning, when I said to you not long since, that If a Schill za was not in good health when this disease a tacked him. Did I sell you hat in the hearing of others, as well as of myself, he voluntary admitted the fact, making a joke of it as ledid so? He'll had that it's na joka now. His body is at this moment a mass of complicated compliant. He may pull through the thack, I shall judge bette to morrow; but I think it probable that within a very short time from now we may be driven to an operation of the through one which is too frequently the

They were by the case in the garden; at coching Grenville's arm, the local or you.

tired as he was, VIII For a had no wish to do the middle of whelmin delight night The dowers the of the night the remoter parts of stars, SCOTA full of moon ller shared tolinge - Plante to Int faithful slept ten for him, be easily and adrest was

His first care next morning was to inquire about the con-

diviously the Prince of As I ambother too all not more in the state of th put a while in the to be strong of the strong was rolbragic service uniquic could rithe all The wrong States and a mostly the ductor hands. mo. indicious vield. "Third" the flerick or wit on the fermion of country the the service of service I probable to the contract the notion of the contract the notion of the contract t last week I had my false membrane sent - Sthe mouth of the opera mode no could be to the control of the could be to the could b was said men are northoot sic someties discovering to constant on the get of the and and though the standard of the s Furres and an amy eartist to the the care trens made counting and the a line of the the she Inc ad a complete to refe ha har bed nis collection And 's san' win and o commonly you.

will see the same to worry of set. , tollene say a to service trie are grane w't a mily write it the suggest that the forest the year probabling b the were the times would be to the whe' The today The Thy writte and add of he of h

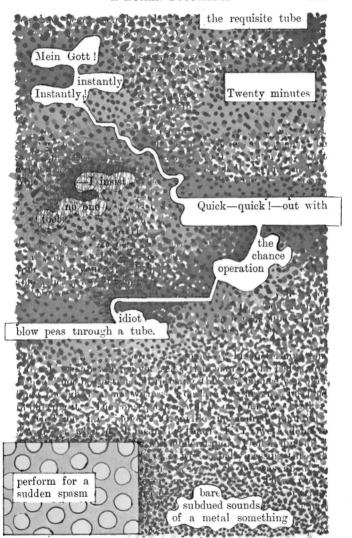

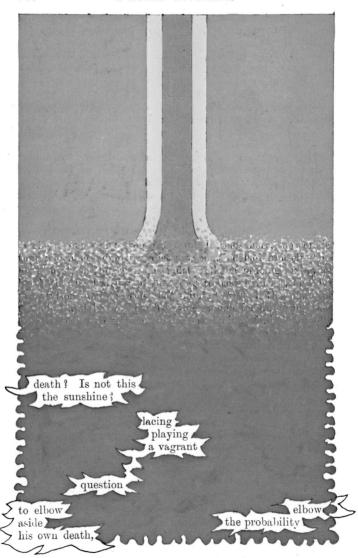

rospects w bsorbed as be had been netical and painty effort he had

t now it presented the him more importante vitty land be felt he me which a night to specular to me produce of a death which he had risked think for feined. his own life to for almoment of two the had aniedly stelled their ocked and dispusted him and he present Dexorrised ringing to the month as the death of he seems for the death of the form of the form of the first towthe seller Mit not pore in her presente, which want in them Adade tropble was a rospes which give nd to the pleasure of some in the relief which unconnected th himself, would come in Regulation the news he brought ith himself woodd come

As he approached the law the first Ling that caught As he approached the lower the mass parasol motionless e was her red dress and parasol motionless sound of books she s sound Fr rned round, staring as him s. The enew near, however, and as what was his enfand e recognized his face a

ne recognized his fake and his expression, and with a smale of hope and of inquiry.

"I have come," he said, "the relieve you high I know must have been wearing you to the note which I sent over his morning to Yes," she said. "How yood of you! relieve you of the a of the anxiety

It arrived

well." he continued, "A have a later bulletin for y was far easier when I left him than he has been for twelve hours. You need not fret yourself because of y ag here. There is nothing you could do for him that is e by his attendants; and mount presence migrat excite he has a later has guite quiet. st with them he is quite quiet.

What has he she said, not asked for me The has asked for no one," said Grenville He has not mentioned your name."

He wondered as he told her this whether she would be thu

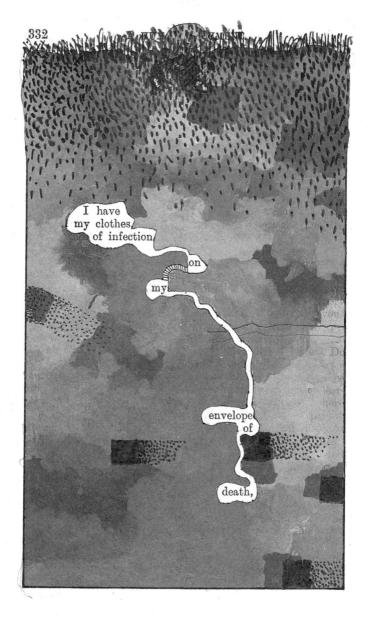

A HUM. UMENT.

on the sofa,

she comes

second time he did so, declared

no question of tension

opened some overwhelming emotion in her lips, gasping.

her

her her words upon her.

"Oh Basho exchaimed provided by "and so you have a count now shave you I have I good that will do You may at lens master voice to a sweethe." Here however, therepwas a preventent made by the doctor a had heep watching Creaville intently, and listening to the Minds projected to himse and new going up to him, and taking the forest the roop will that ensured compliances "the he will, up be to be directly. In the minute of any he will you, Your life may depend upon your prudence. Almost stupeded by the scene he Mad just come through Converte went to his room within and mechanical resignation and the dector returned to the other two before either of then and attended another symbole Sie shift the days will a being In his cheeks was a flush of anger. He strode up to Mrs. Schillzzi, and confronted her with a look that terrified her. "Madame," he said, "that gentleman who has just left us has indeed done what you taxed him with, and kept back from you and begged me to do so also—the most remarkable incident connected with your husband's illness. Seeing, however, the manner in which you treat him, it will be best for you-it will be best for every one—that I tell you the whole truth. I cannot allow you to be ignorant of it. Herr Grenville, madame, whom you charge with having killed your husband, and to whom you say you will never again speak, when your aunt, the Princess, was disabled, and one of the nurses failed me, attended your husband himself during the most trying night of his illness, with a nerve and a care which few trained nurses could have equalled; and when, madame, that operation took place, which you blame him for having concealed from you, it was solely his heroism which enabled it to take place at all. With his own mouth," said the doctor, his voice rising, "he performed the desperate function of removing through the trachcotomy tube the membrane that was sufficialing your husband. No man walking up to a cannon's mouth took his life in his hand more surely than did Herr Grenville then: he did it knowing that the danger was worse even than I dare explain to you; and events will have treated him with a favour which he had no right to reckon upon, if he is not now laying himself down in his bed to await the death from which he struggled to save your husband."

"Doctor," cried the Princess shrilly, "stop-I order you to

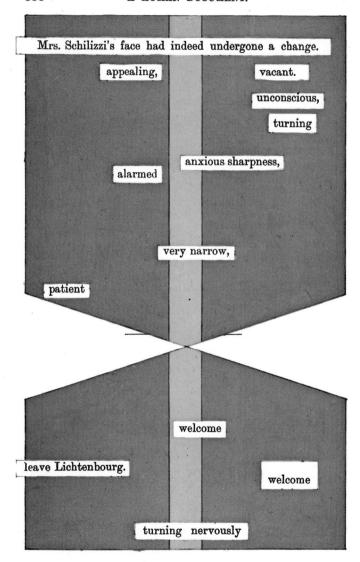

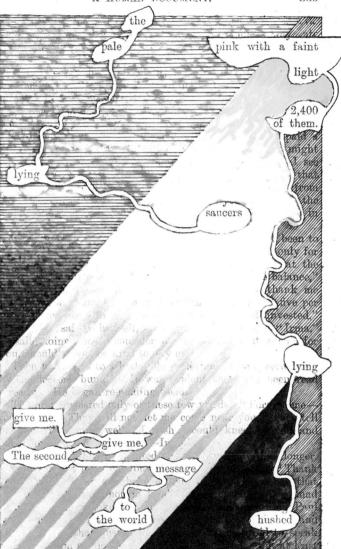

I may tell you I hope you are not suffering. I may comfort myself with the confidence—the doctor gives me this that you recovery still be ratid; and—ones more all foreign me?

Then came those, of which every day had brought one.

"The Princess goes home this afternoon. Her ankle is almost well. I too must leave. I am obliged to again my little ones. Thank you for you few words which I could see you wrote with difficulty itelling matchad my letters soother and dain not disturbly you. I shall drive over to more when now shall I tell you one thing? Dure I? Will you think ill of me form considering what took place yesterday? Will you think II of me form considering what took place yesterday? Will you think II of me form considering what took place yesterday? Will you think II only I will tell you what it was I did. Last night I was told you were sound asteep. The maid had just heard this from your servant, when I asked about you. She was in the passage on side your room. I asked her in look in the passage on side your room. I asked her in look in the passage on side your room. I asked her in look in the passage on side your room. I asked her in look in the passage on side your room.

the liotchest. I saw my little scribbles winz in the table smorgst your medicine glasses. It made me cry to think that such little things could please you."

"I am, ran the next note, "writing this in your hotel. I

have driven over, with my two children, to ask for you, as I said I would send me a line—a word or two; or else a mere massigs. I hear you are much hetter. While if condenly see you! But it would not be allowed me; and under the circumstances I ought not to ask it. Oh, to be with you again, and to hear your lips say, and to see your eyes book, the forgiveness that you have written to me! When I see you negate will you have written to me! When I see you negate will you he outset he same! Are you supe you will?

I shall not be. I shall be changed; but if youlstill on have about what happens to menit is not a clange that will displease

Weak though he was, he had written her a short answer, as hers of the next day showed.

"You tell me," she said, "that the doctor thinks you may nove soon! I had on what do you mean by the ?! You write 'If I die, I eave my dany to you. It is full of you It

(a)) M:Sikvahifa) i (dia	eterem aaterista kuunna muoka amustotata eestomarvote muotaksitela istaase 11000 Radiosis
Ti is an	AND THE RESIDENCE OF THE PROPERTY OF THE PROPE
7 1 7 7	
renery of ann	THE RESERVE OF THE PARTY OF THE
erender i de Sele	th arms on man A data and a sound of A/A & states or handles at \$2
een. Where	will you go! You will brink I am you seemone
or the first t	houghs, in my mind when I ask that question is
shadhan wan	THE PARTY OF THE PARTY OF THE PARTY OF THE PARTY OF THE PARTY.
me : Han'	Palathyt Robby Poll moul vory plans Need
	TO SEE THE PARTY OF THE PARTY O
	THE PARTY OF THE P
overewante.	getting quite
trong again.	CONTROL OF THE PROPERTY OF THE
wiet at first	Annual desirement of the statement of th
n their mind	Annal to the forest
s in the day	s all the control of the same of the control of the
moseovensa sas	The state of the s
CONTRACTOR OF STREET	con ?
etting stron	
MENTAL (O) SECURITY OF EAST	egentalenter er er gemeen en becker which was lying
Charles and Conscious and Cons	M. SCATALON CONTINUES AND
ter Henry	The second of th
SALES SECRETARIAN SECURIOR SEG	
oraniamini (de la Barbara de la Santa de l	The state of the s
NE ep nextro	
STREET, STREET, STREET, STREET,	
THE SHOWING THE	
R ROAD S ETPENSION SEE SE SE SE	INVESTMENT AND STATE OF THE PROPERTY OF THE PR
Jonne hener	TO NOT THE OWNER OF THE PROPERTY OF THE PROPER
o make the	suggestion myself, but I was hoping and dream
	Control of
mill ondon	
	do sesse rooms to our would out like to make
HOSE GIBRE OIL	Gentiform Companie Table Mention of the Anna Anthropological Anthropological Anna Anthropological Anna Anthropological Anthropological Anna Anthropological
100 4 9 4 7 400 V J 400 V 7 9 9 9 9 9 9 9 9 9 9 9 9 9 9 9 9 9 9	micro to a move Soute and the suffer Maintenance and Maintenan
now that ca	ch day you as growing stronger, a daplicate o
our beath o	cems to be springing up in who, call, the memo
September 1	The process of the post of the party of the
ow II william	meet you that if you can give me a few hours
703.4170	I sho mawous and spassan said aven a mesant
HERMANDINE TITE	DV SUBDUSE WOHLD DE STSHOCK TO ME
TANK SAKSING AL	DI (GREAL PRO-MOTO DE DE CASA DE LA CAMBINA DE CASA (A DE DECEMBRO LO LA REVARE CIDENCIDADE PART
come with to	owels and hot water, and, opening the window a
April de la companie	ed a mission of leaves, and a breach of summy an
al Maria Walk States I've Pal	医动物性的 医克格特氏试验检试验检试验检验 化二氯甲基苯甲基苯甲甲基甲基苯甲甲基甲基甲基甲基甲基甲基甲基甲甲基甲甲基甲甲基甲甲基甲
cented with	carly common I (Nonville SIUH) a soul enterin

of an unbelievable sympthing to to which his town expanding. Brown lately vacated by the Primers This that Exercion in the covirons of Cichtenbane the wall the work on the morning when explanate to him that which without he wently company and banish himself to the murating to had turnily known where to sunder, the mald some harry memory of how which would then har BOD OWN to them the happy membries armin which been South of this person with The Sundy difficulty new was, what word Be was been blessures, and he throughout his meal. Which of Instant found him Mich Charles the whole provided the with High thursday bosomed the market and the same to the s broke out into masses of white and pink that falls penetrating mories mories verywhere, like the slowers and the their on The heliton that evening the bin the maximuted Chan that the chose CO SE PO TO TO THE WORLD WARE OF THE THE churcions, and a his would not bravel too has continuously might leave Lichtenberry Roxl Car presently savouldty of Chands of going ? The question causel w Cto creations of its creditably Have nie whohever I wish to go to her but Apritma toutle hotels inthe forest, " s fliour there was leadthy and brachig Hegres, At In fact, he said, 4 I should advise w there the vou are onite strong dealing MATTEROW Said Greaville, "Limistias Buestion, and Latrist won to answer candidly that my health in any way has suffered, of from what Llayer gone tarongh he I say in any war Avillman anistanderstand the tuckning & 4 than it was some ter days ago

have been either a doubtful or a painful one. I carnot say you have suffered has left absolutely no effect on you; but the effect, I can tell you confidently, will be no more than this : your throat may be more delicate than it was before -more liable to the attack, say, of some form or other of laryngitis. I must advise you then to take great, though not excessive, care of yourself, and not to neglect precautions at which otherwise you might have safely laughed.

The first thing next morning a messenger was sent to the hunting-lodge, with the announcement that Grenville would follow in the course of the afternoon here. carriage being heavy, the journey was store anticipated, and it was five anticipated, and it was five anticipated as showing him into the factor that have so vividly familians and the store was so vividly familians and the store was a come of the store of the store

"I will wait in for your come I wonder if you would be able

He sat down, fatigued a about him for a minute would hold flowers was flowers, but there were atain neighbouring divined that these will come dew, had once garden, which be bin rifled in the hash of He longed to hash

THe longed to os only prudence, but an actual senses can to write and despatch

im not very strong yet ne chidren with you." a folded scrap of An answer

come. heard in the passage a street of light test. There was a light knock at the door and a transfer work of the came close to him, and gave him truly area to be kissed. He looked for their mother. They had best the door open. He knew she must be coming. She stood presently in the door way. Above her soft black dress, her

musta record there a around the more was much easy b b pression pore nothingbut Lam net comes mve vou stand dir and Lwillbring mine beside you. tenderly. a montant she little her finger our on his aured, lob smiling two lines of Shelley's My Mary is on thy brow, Asset my pivit on thy brain." ausked bin how She told him about the health Then is a low tone she said a word or two Donald routhy house boom of that I had nearly which really at last quistost and witness borne by wouldn't believe my soul though thut said the fancied it was believe it. World the winner Ningston the more convi In their v of sorrow, but tribute of catastrophe. the ripple talk, in which of death the laugh of Ai speak to them struggle with a d ture tragedy flitted from one gradually became were busy and getting arrived to summon them but

way, and twill watch them from the common cach a fairy to show her. Only mind, it must be a good tries.

She and Grenville went into the balcony, and watched the two small forms flitting about below them. Presently from a chanpof bog-myrtlerost a large pale winged moth, to which the children instantly gave chass, funding into the air, and reaching their hands towards it has watched this incident, Mrs. schilizzi laughed. The sound with that unconscious ripple which Grenville knew so with turned to her. Her face was bright with a happy single. For my smalle like the year's first snowdrop.

"Bobby," she said : reministrate say out too long, look so worn and thind." Stir had better some in now.
my arm; you are and countried to that of face."

she closed the render of plant to beat of are.

She closed the render of the plant to beat a part to be the plant to be the pl

before separating that if the mathematics weeks enough the services and a second of the services where the services is the services of a second beech one whose whose with stem of the services. The merature through with it all the a craft the second have wished for. The second air too like them like sepid water; and they hove withouthe children along the remaindered tree is above which the squirrols still leads in the branchess. They frank the plade they sought; they found the very boutstree. They sear

They would be really realize they make of their prose ASCALOG MANAGOTA TO COLLEGICAL MANA MANAGOTA POR MANAGOTA The state of the s "Well me," she madinared, "what that de la companya de speak first The well he will see at the so smetimes, as ethes I don't there so What I too how it this that wild our consolidation mything on matter how much have at least offered been the utness in them we con "Tota" she said Alleve indeed done Ao. I too wanted by debt as you alle Do you think any my mere ment complete end oh? With course of regits, we what saveled like to describ The course of represent what was the course to take the course of the co went bu "it often no end show OHPHON DE LOS WO turn the dark

Non-build before we see able without offending the works to establish a relationship between ourselves which the world can recognize, some time must elapse. If we alone were concan recognize, some time must elapse. If we alone were con-cerned such a question bed not trouble us. I can never be yours more truly than I am at the present, but just as one dresses oneself in order to go into the street, so, if our relations ship is to be shown to the world syntamity, it would be an outrige not to dress it at the world's prescribed formalities. With me, then, the practical question is this. How, till this is done, can we best remain together? Shall I tell you what I have thought of?

"Tell me."

"Do you remember how often I have talked to you about Italy? If we find it suits the children, shall we travel for some months there say with the winter? This could be done without consing the least remark. Whenever it was desirable we might stay at different hotels. There need be no division between unicomputed the grader eye; and if we are only wise in choosing our times and seasons, we need encounter no eye

that would have any interest in observing its. What do you say, Irma? Speak to me. Tell me your opinion."

"Oh," she said at last, "it is all too delightful. Only Boby.—I wonder it will understand me,—I don't feel that just yet it is ril.

"Never mind," he is the to think of it."

"Never mind," he is yet to think of it."

"Never mind," he is yet to think of it."

"Never mind," he is yet to think of it."

"Never mind," he is yet to think of it."

"Never mind," he is yet to think of it."

"Never mind," he is yet to think of it."

"Never mind," he is yet to think of it."

"Never mind," he is yet to think of it."

"Never mind," he is yet to think of it."

"Never mind," he is yet to think of it."

"Never mind," he is yet to think of it."

"Never mind," he is yet to think of it."

"Never mind," he is yet to think of it."

"Never mind," he is yet to think of it."

"Never mind," he is yet to think of it."

"Never mind," he is yet to think of it."

"Never mind," he is yet to think of it."

"Never mind," he is yet to think of it."

"Never mind," he is yet to think of it."

"Think of it when you like.

"Think of it."

"Think of

twilight, the charm of the future began to operate on their fancies, and the scores limmered before them which they hoped soon to visit

Atheunomentary xpickure of Ataly with which once you struck and dazzled me w I remember your very ou lakes with sails like the breasts of of the bure Correct mountains, rising out of viol and dittering in a sky of primrose colour the notes of roses round us are fratting the murnle she said will not trouble Whatever we ought to think united lives will teach A Phis programme began to be realized recovered strongth rapidly, and matters connected with the estate of her late husband made it desirable for Mrs. Schilizzi to go for a few days to Vienna Grenville accompanied her, how without anxiety. One morning when as usual ha comnow without chariety. One morning when, as asked, he came to live apartment to breakfast with her, the metaling with a look of excitement, holding in her hand a letter "What do you think?" she exclaimed. " At tt. Paul never told me. I have just heard it from Jewy Alawyer A Ath was A Barul who hought want Abonse Athat Alae Queen, or the nation I don't understand these things-Ashan & surprise, Chenxilla sonk Moxux an a sofa saxing the receivestion came back to him of Mr. Schilizzi in the train, and his glowing account of his operations in country A ALLEN AND SAIN DESCRIPTION AND ADOUT A TO So far as I can gather, he wrote that night in his diary, a could it, we liked return to my old home and five there. Thiese it is result and there is no obligation to sell it it will entirely go to Ima, my little step-daughter? but it seems DOCOTO COO DOC CONTROL DO CONTROL am glad of this, and she is glad also. We are glad we might

this point dd This is your detory r porther of us really believe Vat at Fange but we do feel that I not him any benefits Irma's busing here we start to-morrow. We start for an unbelievable dream. said I had not. I said that I felt as if to do so would seem like implying a doubt of her. She said, 'Nd-ho. please Other you should feel that; but indeed you need I know that you don't doubt me; but I have been thinking over the past, and I am horrified to see how capricious and cruel I must have appealed to you. You have thought me capricious and cruel. Don't deny it. Thom won have. Hush don't answer me vet. Let me go on speaking. don't think me so new you don't any longer doubt me; but as to the past, Ilem certain you do not understand me. will if you read my diary. That was why I sent it to you, "I told her I would read it; and we talked o matters, but just as I was going to leave her the came back to the subject. She spoke half shyly, 'When you rend it, she said, 'don't speak about it to me. I want to know that yu have read it through as a whole; but I don't think I cold bear-you see you have all my inmest thoughts there-I don't think I could bear to speak about them in detail, Gen to you. Do you understand me?' I said I did and I did. I shall open her volume for the first time to hight : and each night during our travels, when I am along in my own The day following, as had been arranged, they all started for Italy; and he studied the diary night by night as he had

found himself deviating from the course he had anticipated.

age brighter

A HUMAN DOCUMENT. turning to the records of those days those days notes of rapture turned against the shadow GOLD AND SILVER spinning

help

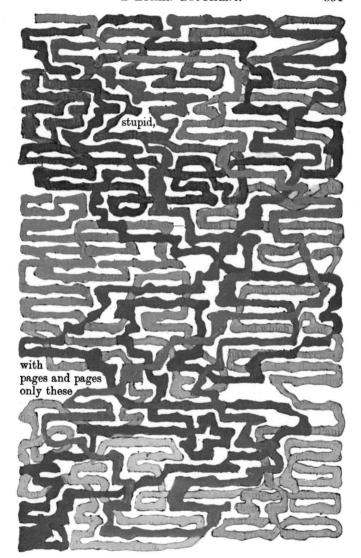

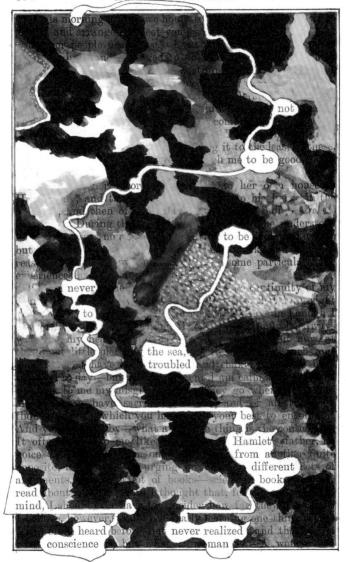

DIVERSITATION OF THE PROPERTY scoring that she seed how over way in perpenty. It value super de report regent we are and There is held to held him alone. Furnacin comes the ansa micro interests magnification by the contion of microside formion, that I are not by the group to rook to a make a continuous to the continuous of the continuous of the first stones cast survey the first stones cast survey the first stones cast survey to as Words-words! Make me

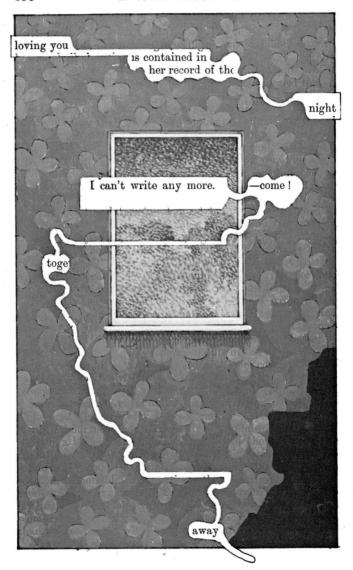

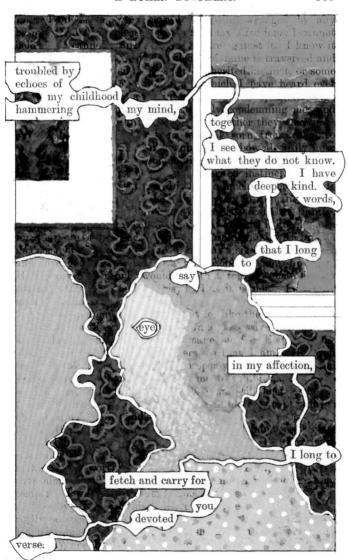

sry much to you, and I feel angry for that you reason as vent my anger on you.

" Last night you were cold and distant. I was, I know but I didn't want you to be. If you could only have a life more penetration, you would see that when in speaking to you have seemed most hard and odious, I have really been onging to cling to you, and tell you I was your own."

Presently came this passage, which, as Grenville read it, ser

he blood to his cheers the blood to his cheen "I have driven you are gone mad it you had stayed at least thought so. And you are gone. The followed this, written during its the Pasha. "I said I would write no more till I saw ou, till I had you

"I said I would write no more till I saw ou, till I had you with me again. But I must write must ease my mind somehow. When are you coming back? Everything is blank without you. Paul is rather poorly. I have been nursing him as much as he would let me. That at all events was a duty. But he would let me do little. He preferred the company of what shall I call her? my rival—one of my twenty rivals: and most of my time I am alone. Oh, Bobby—what can I do without you? You will come back soon, won't you? I don't know how to write to you."

Next day she wrote, "The children are both ill, as well as Paul; so I could hardly see you now, dear, even if you were here. All day I have been by their little beds; but all through my care my heart is aching for want of you. I believe you

here. All day I have been by their little beds; but all through my care my heart is aching for want of you. I believe you will come soon; for cruel to be seem to have treated you, I believe in you so entiry to body, and sick in mind. Come to me the same period, Green to the same period, Green to the secrets of the volume and gone. The replacement of the secrets of the volume and gone. The reading her account that had pained and troub I him was explanation. He had felt, whilst reading her account to the replacement of the secrets of the secrets of the volume and gone. The had felt, whilst reading her account to the secrets of the volume and gone. The had felt, whilst reading her account to the part of the secrets of the secret to be the secret of th

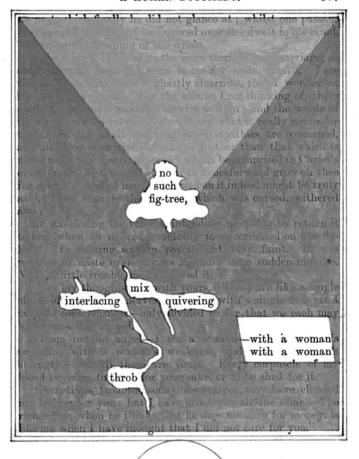

CHAPTER XXXIV.

Comparing this finished his reading on the night of the arrival at Vicenza. They had travelled leisurely, storming three times on the road; and each aight before he composed himself to sleep he had studied her pages by the light of two leven deeper arrival anything he had known before the confidence even deeper arrival anything he had known before think wells of its vision. It is a put the walling he had known before think wells of its vision. It is a their and dingy from which he wall had been paged at the curtains and the confidence in that very town the light of the paradien light. The voices of singing it air. Grenville thought of the remembered morning.		
arrival at Vicenza. They had travelled leisurely, stoppin three times on the road, and each night before he composed himself to sleen he had studied her pages by the light of two self to sleen he had studied her pages by the light of two was now not expected by him he had known before. Faith was lost in vision. It is a light had known before. Faith was lost in vision. It is a light had known before. Faith was lost in vision. It is a light had always make the summer with lowers in routed the curlains. In the morning he hosts, haunted the curlains. But he hosts, haunted the curlains. But he hosts, haunted the curlains. But he hosts, haunted the curlains. In the morning he hosts, haunted the curlains but he was larger than the was larger than the was larger than the was larger than the head of the warm of the curlains. In the morning he had to be warm that the curlains and together than the head of the warm was light. The voices of singing is air. Grenville thought of the remembered morning.		GRENVILLE finished his reading on the night of their
They were staying at different hotels. In the morning he sions were made by them, from light. The voices of singing pair. Grenville thought of the self-state and toge single thought of the single th		arrival at Vicenza. They had travelled leisurely, stopping
was now not and discussed but had ever troubled him was now not and discussed but had given phee to a confidence even deeper living a plant he walking the land known before. Faith was lost in vision. It is a plant he walking the land known before. Faith was lost in vision. It is a plant he walking the land known before. Faith was lost in vision. It is a plant he walking the was like paradise. He was low in that very town the land consumed one horse and he walking the land consumed one horse and he walking in that very town the land consumed one horse and he walking in that very town the land consumed one horse and he walking in the walking		Unree times on the road, and each might before he composed him.
was now not a control of the control		self to sleep he had studied her pages by the light of two
was now not a decided but had known before. Faith we lost in vision. It is much the volume dawn, he was pring in great gaunt to the walls of the wal		PARKETHINITH HINGHING
was now not a decided but had known before. Faith we lost in vision. It is much the volume dawn, he was pring in great gaunt to the walls of the wal		regard to her that had ever troubled him
even deeper May a which has been been been been been been been bee		was now not work distributed and a long to the first
lost in vision. great gaunt to the state of		even deeper Provide
walls of temper to the contains and the curtains and to the curtains and the curtains are closed his eyes be the place was like paradism. In the morning he impregnated all the air flowers, girls on the pavement. It was a dream come and toge they provide the curtains and toge the curtains and the curtains are considered and the curtains are considered and the curtains and the curtains are considered and the curtains and the curtains are considered a		
walls of temper is the state of the curtains and the curtains are impregnated all the air flowers, girls on the pavement. It was a dream come and toge and the curtains and toge and the curtains		great garnt Reight
They were staying at different hotels. In the morning he impregnated all the air. It was a dream come life and toge lives produced by them, from light. The voices of singing pair. Grenville thought of the remembered morning.		
Musty smells, the body place was like paradist. He was have in that very town. They were staying at different hotels. In the morning he impregnated all the air. flowers, girls on the pavement. It was a dream come life and toge livey prositions were made by them, from light. The voices of singing pair. Grenville thought of the remembered morning.		
They were staying at different hotels. In the morning he impregnated all the air flowers, girls on the pavement. It was a dream come and toge incy prosions were made by them, from light. The voices of singing pair. Grenville thought of the remembered morning.		Must verically shows
They were staying at different hotels. In the morning he impregnated all the air flowers, girls on the pavement. It was a dream come life and toge life and toge life and toge life are remembered morning.		alogod his over the latest manner the curtains. But he
They were staying at different hotels. In the morning he impregnated all the air, flowers, girls on the pavement. It was a dream come life and toge hey prosions were made by them, from light. The voices of singing pair. Grenville thought of the remembered morning.		in that your table
They were staying at different hotels. In the morning he impregnated all the air, flowers, girls on the pavement. It was a dream come life and toge her prositions were made by them, from light. The voices of singing pair. Grenville thought of the remembered morning.		the carel-state of the control of the carel-state o
They were staying at different hotels. In the morning he impregnated all the air, flowers, girls on the pavement. It was a dream come life and toge her present air. Grenville thought of the remembered morning.		
sions were made by them, from light. The voices of singing air. Grenville thought of the remembered morning.		
sions were made by them, from light. The voices of singing pair. Grenville thought of the remembered morning.	-	they were staying at different notes. In the morning he
sions were made by them, from light. The voices of singing pair. Grenville thought of the remembered morning.		impregnated all the air
sions were made by them, from light. The voices of singing pair. Grenville thought of the remembered morning.		nowers, many and a second seco
sions were made by them, from light. The voices of singing pair. Grenville thought of the remembered morning.		girls on the pavement.
sions were made by them, from light. The voices of singing pair. Grenville thought of the remembered morning.		onder It was a dream come
sions were made by them, from light. The voices of singing air. Grenville thought of the remembered morning.		
sions were made by them, from light. The voices of singing air. Grenville thought of the remembered morning.		
sions were made by them, from light. The voices of singing paints melted into the warm air. Grenville thought of the remembered morning, well make alone. He learnt to		
light. The voices of singing promits multiple into the warn air. Grenville thought of the remembered morning, will which, on a dump, well remembered morning.		
air. Grenville thought of the remembered morning,		
remembered morning.		light. The voices of singing possents melted into the warm
		air. Grenville thought of the which, on a damp, well-
The second secon		
THE PARTY OF THE P		

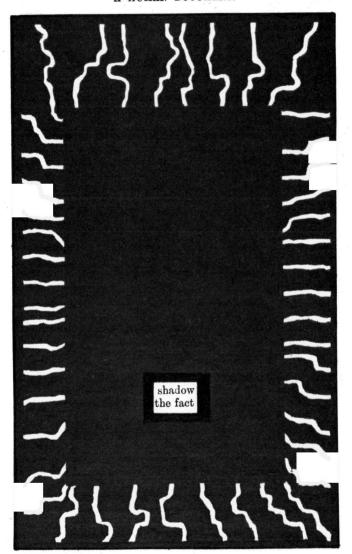

Sir Septimus Wilkinson, shining and swelling with the wish to be intimate

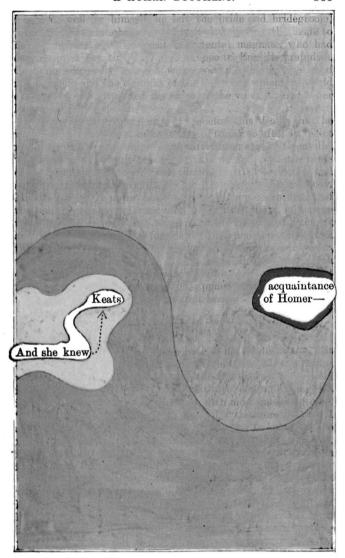

ospecially when crushed us, and slowly changed, old prejudices value on which all out off been raised up old prejudices have reason, against to betray my m to ulcerate my men hess. But they ha avord a laugh and "I only mean," that to me is a pier but chilly, and if I tal me I may do so. I grove of stone-pines. will come with me, perland you

n creature on be is a large with the large print, by black the large print, by black the large print, by black the large print, by large point, by large print, by large print

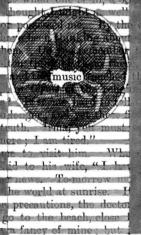

will understand it."

He He The special state indicated was just below the girden and could be reached by a winding road, bracticable for a light carriage. In the mast of the mouning, when the light was a white dimness, a little praychaise stood at the villa door; and Grenville and his wife crawled in it down the steep descent, whose rough zigzags brought them close to the sea. In the universal stillness the roise even of that light carriage was starting. Draft store which the pray's needs loosed has been numbered and the ground was soft and velvety, one sound alone came to their listening ears; and this was the long sigh and the falling murmur of the waves.

They stationed themselves on the margin of the grove, just where the sands bordered it. The air was fresh with the night which had hardly left it; and the darkness of the night was still in the solemn blueness of the sea. Before them for miles and miles were the curves of the vast bay ending in a horn of mountains, which were now half lost in mist; and along the sea-line, and over the high hill country inland, white houses were sprinkled on purple and gray shadow. But all as yet was sleeping. Even the waves fell like a dreamer moving on his pillow. Nothing was awake but smells of brine and dew.

dew.

"Let me there the world, he said as a low voice to her "Let me inhale the morning. Ah there is life—life, everywhere. Soon you will see it waking. Look, look!" he exclaimed, as an arrow of rosy gold shot through the nir and struck on a crest of feam. And now a change came. Far away the mountains began to flush; coloured vapours steamed out of distant valleys; and wreaths of smoke from one place and another were seen rising in columns of shining silver.

She felt it difficult to speak. She could only look armitim anxiously.

"Did you ever," he asked her presently, "hear a story of Mirabeau I dare say unit ue, like most stories of death-beds how he told them, as he was dying, to throw the window epen, and said, 'Srinkje me with rose-buds, crown me with flowers, that I may so enter on the eternal sleep 'I I think that was rather theatrical; but still I can feel a meaning in it. I should like to be buried where flowers might sminkle my gazae in pour con gaption. It spece tall your time times that

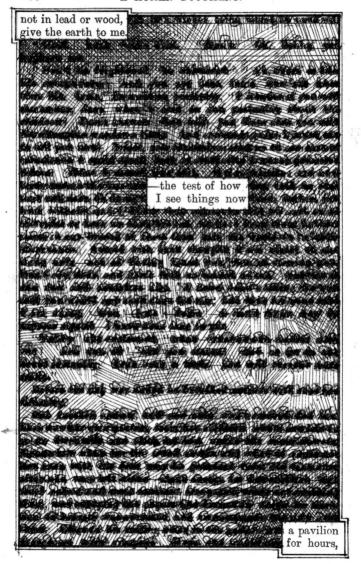

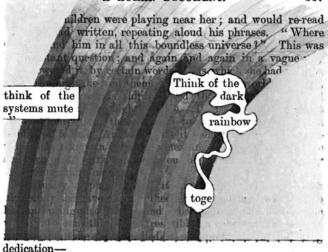

"TO THE SOLE AND ONLY BEGETTER OF THIS VOLUME.

with the bones my bones find nargin and whose lists half meets in the saper the violets accree on gravitate that the saper the violets accree on gravitate to come lack to row in feath, a perpetuate that within the come lack to row in the one single life in the control of the

Jan plants was

NOTES ON A HUMUMENT

Like most projects that end up lasting half a lifetime, this work started out as idle play at the fringe of my work and preoccupations. I had read an interview with William Burroughs* and, as a result, had played with the "cut-up" technique, making my own variant (the columnedge poem) from current copies of the *New Statesman*. It seemed a good idea to push these devices into more ambitious service.

I made a rule; that the first (coherent) book that I could find for three pence (i. e. $1^{1/4}$ p) would serve.

Austin's the furniture repository stands on Peckham Rye, where Blake saw his first angels and along which Van Gogh had probably walked on his way to Lewisham. At this propitious place, on a routine Saturday morning shopping expedition, I found, for exactly threepence, a copy of A Human Document by W. H. Mallock, published in 1892 as a popular reprint of a successful three-decker. It was already in its seventh thousand at the time of the copy I acquired and cost originally three and sixpence. I had never heard of W. H. Mallock and it was fortunate for me that his stock had depreciated at the rate of a halfpenny a year to reach the requisite level. I have since amassed an almost complete collection of his works and have found out much about him. He does not seem a very agreeable person: withdrawn and humourless (as photographs of him seem to confirm) he emerges from his works as a snob and a racist (there are extremely distasteful anti-semitic passages in A Human Document itself). He has however been the subject of some praise from A. J. Ayer for his philosophical dialogue The New Republic, and A Human Document itself is flatteringly mentioned in a novel by Dorothy Richardson. However, for what were to become my purposes, his book is a feast. I have never come across its equal in later and more conscious searchings. Its vocabulary is rich and lush and its range of reference and allusion large. I have so far extracted from it over one thousand texts, and have yet to find a situation, statement or thought which its words cannot be adapted to cover. To cite an example (and one that shows how Mallock can be made ironically to speak for causes against his grain); I was preparing for an exhibition in Johannesburg (May 1974) and wanted to find some texts to append to paintings; I turned (as some might do to the I Ching) to A Human Document, and found, firstly: -

wanted. a little white opening out of thought.

^{*} Paris Review. Fall 1965.

and secondly: -

delightful the white wonder
to have the sport and grasses.
The ancient dread
judgement now has come
judgement suddenly, black from a distance.
expected, hurrying on.

Take a new turn back to reason.

More recently, in working on an illustrated edition of my own translation of Dante's *Inferno* I have managed to find a hundred or so parallel texts from *A Human Document* which act as a commentary to the poem. I have even found sections of blank verse to match the translation as in this fragment which forms the half-title: –

My stories of a soul's surprise, a soul which crossed a chasm in whose depths I find I found myself and nothing more than that.

When I started work on the book late in 1966, I merely scored out unwanted words with pen and ink. It was not long though before the possibility became apparent of making a better unity of word and image, intertwined as in a mediaeval miniature. This more comprehensive approach called for a widening of the techniques to be used and of the range of visual imagery. Thus painting (in acrylic gouache) became the basic technique, with some pages still executed in pen and ink only, some involving typing and some using collaged fragments from other parts of the book (since a rule had grown up that no extraneous material should be imported into the work).

Much of the pictorial matter in the book follows the text in mood and reference: much of it also is entirely non-referential, merely providing a framework for the verbal statement and responding to the disposition of the text on the page. In every case the text was the first thing decided upon: some texts took years to reach a definitive state, usually because such a rich set of alternatives was present on a single page and only rarely because the page seemed quite intractable. In order to prove (to myself) the inexhaustibility of even a single page I started a set of variations of page 85: I have already made over twenty.* The visual references used range from a telegram envelope to a double copy of a late Cézanne land-scape.

^{*} some of which have already been published in A Humument Supplement (Tetrad Press), OU magazine, and Six variations (Coriander Press).

The only means used to link words and phrases are the "rivers" in the type of the original; these, if occasionally tortuous, run generously enough and allow the extracted writing to have some flow so that it does not become (except where this is desirable) a series of staccato bursts of words.

Occasionally chance procedures have been used. One page (p. 99) executed in this way was first divided into half, and, by tossing coins, every word except one was eliminated from each half. Once again the book spoke (like the *I Ching*). Its two words, in a faintly Jewish voice, said (in 1967) "something already". The title itself was arrived at by invited accident: folding one page over and flattening it on the page beneath makes the running title read A HUMUMENT, (i. e. A HUM(AN DOC)UMENT), which had an earthy sound to it suitable to a book exhumed from, rather than born out of, another.

The numerical order of the pages is not the chronological order of their making. The initial attack on the book was made by taking leaves at random and projecting the themes that emerged backwards and forwards into the volume. In the end the work became an attempt to make a *Gesamtkunstwerk* in small format, since it includes poems, music scores, parodies, notes on aesthetics, autobiography, concrete texts, romance, mild erotica, as well as the undertext of Mallock's original story of an upper-class cracker-barrel philosopher, ex-poet and diplomat, who falls in love with a sexy prospective widow from Hampstead (her husband is out of combat, being a sick man, and, being a Jew, beyond the pale in any case).

Many rules have grown up in the course of the work. Although Mallock's original hero (Grenville) and heroine (Irma) have their parts to play, the central figure of this version is Bill Toge (pronounced "toe-dj"). His adventures can only (and must) occur on pages which originally contained the words "together" or "altogether" (the only words from which his name can be extracted). He also has his own recurrent iconography; his insignia include a carpet and a window looking out onto a forest and his amoeba-like ever-changing shape is always constructed from the rivers in the type. His story, the Progress of Love, is a favourite neo-platonic topus and there are deliberate parallels with the Hypneratomachia Polophili, the most beautiful of printed books, published in Venice in 1499.

As well as A Humument itself, Mallock's novel has been the source for other ventures, notably the complete score of an opera IRMA* whose libretto, music, stageing instructions and costume designs all come from A Human Document. This received its first performance in Newcastle in 1973 which was followed by a performance at York University in the same year and has recently been recorded in a version devised by Gavin Bryars (Obscure Records). Other offshoots include Trailer (published by edition hansjörg mayer, Stuttgart 1971) which is in

^{*} first published in OU magazine 1970 and reprinted by the Tetrad Press in 1972, and by the artist in 1978 in conjunction with Waddington Graphics as a silkscreen print.

effect garnered from the cutting floor of A Humument, though a self-sufficient work, and DOC, a series of affidavits and testimonies which attempt to build up the picture of a lecherous doctor. There exists also a large number (about three hundred to date) of self-contained fragments, small paintings which make variations of wording and design from the book itself and catch up on some lost opportunities in the original. Texts from the same Mallock novel also appear as pendants to paintings such as the series The Quest for Irma (1973) and Ein Deutsches Requiem: after Brahms. In preparation is a ballet scenario (with score and costume designs) which could either be performed separately (as The Quest for Grenville) or as an interlude in performances of IRMA.

As work went on and ramified, a second copy of A Human Document became necessary. Curiously enough it turned up in the other branch of the same furniture repository (though this time it cost 1/6d). This copy had belonged to one Lottie Yates who had herself "treated" it to some extent, heavily underlining passages that seemed to relate to her own romantic plight (occasionally in the margin she had sighed "How true!"). It seems also that she had used it as a means of saying to her beloved the things she lacked words for, passing the underlined copy to him as a surrogate love letter. Thus, in 1902, someone had already started to work the mine. The first copy had belonged to a Mr Leaning and was unmarked save for his signature. I have since acquired twelve copies. Most have no sign of their owners: one, however, which was purchased at the Beresford Library, Jersey, in 1893, by Colonel J. K. Clubley, passed eventually into the hands of someone who merely signs himself "Hitchcock". The most recent addition has been a copy supplied by a well-wisher from the library of Sir Gerald Kelly, a past president of the Royal Academy, though how he got if from "Nell" to whom it was presented by "Michael" in 1901 is not recorded.

I have so far used up seven copies of the novel to make A Humument and its derivatives; I am now well into an eighth. I have yet to find a copy of the original three-decker first edition which I would greatly like to work on.* To help me locate certain key words (when tackling the Dante project for example) I have, with some help from others, compiled a complete concordance to A Human Document.

All the work on A Humument has been done in the evenings so that I might not, had the thing become a folly, regret the waste of days. One kind of impulse that brought this book into slow being was the prevailing climate of textual criticism. As a text, A Humument is not unaware of what then occupied the pages of TelQuel (and by now must already have become a feature of undergraduate essays). Much of structuralist writing tends to be the picking over of dead words

^{*} If any reader knows of one for sale, or indeed of any further copy of the popular edition I should be grateful for the information.

to find sticks for the fires of cliqueish controversy. A Humument exemplifies the need to "do" structuralism, and, (as there are books both of and on philosophy) to be of it rather on it. At its lowest it is a reasonable example of bricolage, and at its highest it is perhaps a massive deconstruction job taking the form of a curious unwitting collaboration between two ill-suited people seventy five years apart. It is the solution for this artist of the problem of wishing to write poetry while not in the real sense of the word being a poet ... he gets there by standing on someone else's shoulders.

Publication of *A Humument* was started in 1970 by the Tetrad Press with a box of ten silkscreened pages which made up Volume I. Other volumes (ten in all, containing varying quantities of pages) were printed by lithography, silkscreen, and letterpress in a limited edition of one hundred copies. The original manuscript was completed in the autumn of 1973 and was shown within days of that event, in its entirety, at the Institute of Contemporary Arts (in whose bulletin, then edited by Jasia Reichardt, it was first mentioned in 1967).

This first edition in book form differs from the private press edition in that several new pages have been substituted for the first versions and many other pages have been reworked by hand, using the advantages of revision offered by the preparatory stages for colour offset lithography. If this book finds favour (i. e. sells), and I live, the consequent reprints will allow me to replace say a dozen pages with each new edition. A notional thirtieth (!) printing therefore would be an entirely reworked book with almost no pages surviving from the first.

In a sense, because A Humument is less than what it started with, it is a paradoxical embodiment of Mallarmé's idea that everything in the world exists in order to end up as a book.

T. P. 1980. This is a revised version of the Notes printed in Works/Texts to 1974 (Edition Hansjörg Mayer) which were themselves adapted from an article in the London Magazine in 1971. It is here reprinted from the Thames and Hudson edition of 1980. As readers will see the promise of the penultimate paragraph has been kept. Since that edition *The Heart of a Humument* has appeared (Edition Hansjörg Mayer) which explores only the central section of some of the pages of *A Human Document*. Mallock's text has been further plundered for various works, e. g. "A Course in Sussex" (screenprint) and the graphics produced for Wine Arts Ltd dealing with the chateaux of Bordeaux. There are rumours of a French translation.

The following have acted as patrons of this revised edition, each of them having underwritten the changing of a page. It is through their generous support that the book continues to be available at a reasonable price. To each of them one of the revised pages is mutely dedicated.

Robert Altmann. Michael & June Anderson, Alex Angelides, Robert Anthoine, J-P & M-C Buvat, James Buchanan, Leong Chan, Alan Christea, Melanie Connell Chris Corbin. David Damrosch. Raymond Donovan, Angela & Matthew Flowers, Anthony Fox Franklin's Antiques, Ionathan Hills, Philip Hughes, Jeremy King, Michael Kustow, Norbert Lynton, Iane McAusland, Fiona Maddocks, H, A, H & S Mevric-Hughes, Adrian & Celia Mitchell,

Richard Morphet, Bernie Moxham. Iris Murdoch. Ann Parker, Gernot Riedmann. Josephine Quintavalle, Ruth & Marvin Sackner, Alfred Scheinberg. Andras Schiff, Jack Shapiro, Eileen Slarke, Joe Studholme, Sylvia Sumira, Nick Tite. Marina Vaizey, Hermione Waterfield, Erdmute Wenzel White, Yvette & Stefan Wiener. Patrick Wildgust, Ionathan Williams, Peter Willis. Ira G. Wool, plus three anonymous supporters.

Both artist and book also owe a great debt to Hansjörg Mayer.